T0068968

About this book Politicians and journalists never u.. ̣g to the 'political landscape'. In this book Martin Warnke takes that well-worn metaphor literally, using it to reveal just how politicized the actual landscape of Europe has been for centuries. The evidence he finds everywhere, both on nature's own ground and in art itself: the demands made by conquest or defence, by property rights and picturesque improvement and by trade, tradition, communication and commemoration; and in every form: monuments and milestones, gardens, roads and border-crossings, in landscape paintings, medals and maps. Warnke also provides a compelling summary history of the ways by which the relationship of man and nature has been irrevocably altered.

About the author Martin Warnke was born in Brazil in 1937. He is currently Professor of Art History at the University of Hamburg. He has published extensively on Flemish, Spanish and Italian art, and on iconography and iconoclasm. His previous books include a history of political architecture in Europe, and *The Court Artist* (1993).

Political Landscape

The Art History of Nature

Martin Warnke

REAKTION BOOKS

Published by Reaktion Books Ltd
33 Great Sutton Street, London EC1V ODX, UK

www.reaktionbooks.co.uk

First published in Great Britain in 1994
by Reaktion Books, London

Transferred to digital printing 2009

English edition copyright
© Reaktion Books, 1994

First published in German
© 1992 Carl Hanser Verlag München Wien

Translated by David McLintock

Cover and text designed by Humphrey Stone

Printed and bound by Chicago University Press

British Library Cataloguing in Publication Data
 Warnke, Martin
 Political Landscape: Art History of
 Nature. – (Essays in art and culture)
 1. Lanyon, Peter, 1918–1964 – Criticism and interpretation
 I. Title II. McLintock, David III. Series
 709

ISBN 978 0 94846 263 4

Contents

Preface

The title of this essay seemed unproblematic until the question of the *origin* of the phrase 'political landscape' arose. In response to my enquiry, the editors of the Duden Dictionary in Mannheim stated that it appeared to have been coined by Joseph Goebbels, the Reich Minister of Propaganda, who remarked that Veidt Harlan's film *Kolberg* 'did not fit into the political landscape'. It then seemed that the title would have to be abandoned. The archive of the *Wörterbuch der Gegenwartssprache* (Dictionary of present-day German), published by the Academy of Science in the former German Democratic Republic, could provide no comfort, but only the additional information that 'political landscape' was 'an expression favoured by Willy Brandt and not attested in GDR journalism until 1972', before which time it had been customary to speak of the 'political climate'.

Fortunately a solitary justification for the title turned up in a context relating purely to art. In the *Kunstblatt* for 26 March 1849 Ernst Förster wrote:

> One of the most interesting pictures we have recently seen at the *Kunstverein* is a political landscape by Bernhard Stange. A political landscape! Yes, so far has the spirit of the age advanced! We are at the summit of a high mountain. Mountain tops all around. The tallest is bathed in the afterglow of the sunset; on all the others are flames of fire, which on the more distant peaks look like twinkling stars; in the foreground a German tricolor, planted by mountain-dwellers, blown by the wind and fluttering high in the air. It is a celebration of German unity, anticipated by art and soon, let us hope, to be matched by reality. A beautiful picture, executed with a fine sense of form and colour, in which not one jot of artistic interest is sacrificed to the political. – Yet another political landscape! No, a historical landscape. The battlefield of Marathon by Carl Rottmann. . . .

Art experts, slow to rediscover a religious and a moral landscape,[1] have totally eliminated the political element from

landscape painting, being understandably drawn to the less encumbered 'feelings for nature'.

It is not intended here to confine the familar phrase once more to painting, but to retain its wider application, which also embraces the shaping of the real landscape.

I hope the essay that follows will show that political pointers need not impair our appreciation and perception of the landscape, but can actually sharpen them. It was written at the Cultural Institute in Essen-Heisingen. There I was helped in particular by Brigitte Blockhaus, Martina Langsch, Gesine Worm and Michael Diers, but I benefited also from discussions with all my colleagues, members of staff and guests of the Institute. Finally, I had valuable advice from Johannes Hartau on both the text and illustrations.

1 The Occupation of the Plain

The calendar scene showing the landscape below the castle of Lusignan (illus. 1), one of the illuminations by the Limbourg brothers in the Duke of Berry's *Très Riches Heures* (*c.* 1415), contains a number of simple devices that convey more or less overt political signals.

The roads that quarter the land into neat rectangles are geometrically disposed, like the boundaries on a colonial map. At the intersection stands an ornate Gothic montjoy, carved from stone, indicating the duke's patronage.[2] A similar roadside monument, dating from the early 1390s and known as the 'Spinnerin am Kreuz', stands near Vienna (illus. 2); this is a pointed column donated by the city's mayor and set like a monstrance beside the highway to Hungary.[3] The monument at Lusignan, however, stands not at a public crossroads, but within the duke's private domain. The workers faithfully go about their tasks within a strictly prescribed framework; the ploughman in the foreground furrows a triangular field as if in accordance with a fixed pattern.

The shepherd in the background, entering the picture from the left with a basket of leaves, has to use his sheep to keep a strip of ground around the castle clear of all vegetation, as this would provide cover for attackers. The empty strip ensures that no one can approach the ruler unseen. The adjacent fields must, however, be protected from the grazing sheep. The plastered walls, together with the tower on the left of the picture, the monument at the intersection and the modest gatehouse, form the castle's front line of defence; it was perhaps not fortuitous that a later hand, of *c.* 1500, emphasized these additions to the landscape by retouching them in white.

Such calendar pictures from court workshops, which count among the incunabula of early landscape painting, bear witness not to a new feeling for nature, but to the ruler's hold over his territory; they are political tableaux that register rights and duties, dispositions and functions.

If it is true that 'practically every change in the countryside introduced by human hand (walls, ditches, posts, etc.) is

virtually indestructible and can be rediscovered under the right conditions',[4] then we have hardly any chance, at least in Europe, of finding a single stretch of untouched landscape, unless it has been protected from the beginning as a 'natural monument'. Any normal landscape probably always presents 'a physiognomy shaped by man'.[5] But then, even the biblical Garden of Eden 'was already an orchard'.[6]

Even the simplest topographical features are the results of political decisions. The size and disposition of the fields, the crops that are grown in them and the locations of the farms are determined by re-allocations, 'green plans', agricultural subsidies and control of the market. Fields, patches of woodland, dykes, pastures and meadows are all the outcome of agrarian policies. The different configurations of arable land – laid out in blocks or strips, running in parallel or at right-angles to one another – reflect an ideal scheme under which collective land-use, directed by the local landlord, led to 'regular forms', whereas 'irregular forms' arose when a group of peasants developed the land themselves, largely uninfluenced by higher authority (illus. 3);[7] older forms of cultivation could shape the countryside and so provide a striking historical record of settlement and husbandry.[8] The proportion of arable land to woodland, land-use, enclosures, hunting grounds and commons have always engendered the fiercest local conflicts; in 1793 a 'Karl stone' (illus. 4) was set up at Weinstadt-Endersbach to commemorate Duke Karl Eugen's success in settling protracted disputes between two communities over the local woodlands.[9]

Among the simplest political features of any landscape are the boundaries that separate private, regional or national territories, ecclesiastical or secular domains, and spheres of influence.

Usually a simple embankment, a ditch, a hedge or some other visible indicator will suffice for interpersonal dealings. The keener the sense of private or public ownership, the stronger the need for irremovable, or at least conspicuous, boundaries. Fences, walls and barbed-wire barriers usually indicate nothing more than a personal need for security: they protect private property in real, not just symbolic, terms. If such means are used to secure state frontiers, they suggest usurpation, and neighbouring states often find it hard to accept such frontiers (illus. 5).

In northern Europe it was only relatively recently that borders between nations or states were reduced to mere lines. This form of frontier presupposes that cultivated landscapes have converged, encroaching on the undeveloped land between them, and that peaceful coexistence appears possible.[10] Einhard reveals the extent to which such circumstances could affect relations between the Franks and the Saxons c. 800: 'The borders between our territory and theirs ran for the most part through the plain. Only in a few places did large woods or hills form clear boundaries. Hence endless murder, robbery and arson was committed on both sides'.[11]

Linguistically too, the reduction of the state frontier to symbolic indicators was a late phenomenon. The German word for 'frontier', *Grenze*, is a thirteenth-century loan from Polish *granica*, and until well into the sixteenth century the old word *Landmarke* (whose second element is cognate with the English *march*, as in 'the Welsh Marches'), remained much commoner. Borders were thus constituted by marches – woods, mountain crests, wildernesses, steppes, swamps, moors, lakes or rivers. The primeval landscape was often confined to borderlands,[12] which were wild, exotic tracts. The seemingly outlandish mountain and forest landscapes painted by Roelandt Savery for Emperor Rudolf II (illus. 6) do not necessarily indicate a pathological aversion to nature: they may be faithful depictions of border regions. The spectacular wildness of these border forests could assure a ruler that his frontiers were secure and impassable; other rulers might be convinced of their own security by means of pictures of their frontier castles.[13] To describe such boundaries, including rivers, as 'natural frontiers' tends to obscure the fact that nature was left artificially intact so that it could function as a boundary and so serve a cultural purpose.

The normal need for territorial demarcation was met by the ceremonial erection of a stone whose base was embedded deep in the ground: 'For the most part carved stones and columns are used to mark out the ruler's territory, and accordingly they bear his coat of arms'.[14] It was important, however, that the boundary stone should be not just any natural stone, but one that showed traces of having been specially dressed; otherwise it would not convey the necessary message, as it might be assumed to have always lain there by chance. Nor could a tree indicate a boundary unless it was

specially marked, say with a cross. If a patch of shrubbery was to serve as a boundary-marker, it too had to be shaped; without a recognizable form it could not legitimate the border. As evidence of an agreement between contracting parties, the boundary marker had to be seen to be deliberately shaped.

Boundary stones became common only in the fifteenth century; they were then numbered and engraved with the rulers' coats of arms and official devices, like the one dating from 1787 that marked the boundary of the principality of Mannheim (illus. 7).[15] Buried beneath the stones were the 'boundary witnesses', stone fragments marked with a sign; these provided the ultimate clue to the boundary if the stone itself was destroyed, displaced or disputed. Rituals were enacted around the stones – processions in which children took part and were subjected to mildly painful experiences such as having their ears tweaked (the ear being supposedly the seat of memory) so that they could pass on their know-ledge to later generations. This mnemonic strategy guaran-teed that a particular stone was not taken to be a natural topographical feature, but recognized and acknowledged as having been set up by consent. If rulers or landowners could afford it, folk memory was aided by architectural elaboration. For instance, the boundary column at Rain on the Lech, set up c. 1600 (illus. 8), is a conspicuously tall monitory structure, variously ornamented at each stage.[16] The relief panels on the older column at Burghausen-Raitenhaslach (illus. 9) record the history of salvation.[17] In 1792 Goethe worked such 'edification at the frontier' into a drawing (illus. 10). This drawing shows a stake topped by the cap of freedom, proclaiming the promised land, while in the background on the left 'the sun, with the Bourbon lily, goes down behind a castle, and on the right the moon, with the imperial double eagle, is darkened by a rain-shower. The symbol of republican victory triumphs over the heavenly bodies of monarchy'.[18] Here it becomes clear that the boundary now also 'determines allegiance to certain norms and the areas in which they are recognized'.[19]

Alertness to marked frontiers and respect for boundary monuments and borderlands must once have been much greater than they are today, for until recent times there were neither land registries nor maps recording local boundaries; boundary marks carried ultimate authority and required no

confirmation by a third party. The landscape itself testified to ownership and authority far more directly than was later the case, when it became possible to sue over territorial claims.

Were we to consider all the landscape features that testify to political intentions, the result would be a compendium of political topography.[20] But for the present we will confine ourselves to roads. Since ancient times roads have been not only international channels of communication and commerce, at points along which merchants exchanged their goods, but means of conquest and occupation, along which armies marched.[21] Napoleon's *routes nationales* run in straight lines across every geographic feature and indicate their destination overtly; this was entirely in keeping with the spirit of the absolutist schools of highways and bridges. The German motorways, by contrast, follow the lie of the land (in such a sophisticated manner that Fritz Todt, Hitler's Inspector-General of Roads, wished them to be acknowledged as 'national art monuments'), and conceal their destinations through their sensitivity to the landscape (illus. 11).[22] At an early date rail networks were planned and built partly with a view to military needs.[23] However, roads too have often been routed in such a way as to convey a political message:

> The highway runs in a straight line to the boundary column between Ochsenfurt and Uffenheim. The roads from Ansbach to Triesdorf also run in straight lines and then become avenues where this is possible and necessary. In this connection we still have to consider why the highway from Bad Kissingen to Würzburg always runs straight towards the towers of the village churches, then turns off just before each village, to align itself with the next church tower.'[24]

A road may have a number of features whose political aspects are not always obvious, although when we learn that in the first half of the nineteenth century King Ludwig I had milestones set along all Bavaria's military highways 'in the Roman manner',[25] it is clear that he wished to demonstrate his hold over his territory.

Road-building initiatives have often been political in origin, and in modern times they therefore tend to be marked by monuments. Back in 1492, for instance, the royal bridleway to Italy through the Tyrol was converted 'under Duke Albrecht IV of Bavaria into a solid road between the Kochelsee and the

Walchensee'.[26] In 1543, to commemorate the re-routing of the highway at the head of the pass by the Kaplanhaus, King Ferdinand I had a bronze tablet set up (illus. 12); this bears an inscription stating that the road was built 'for the common good', together with reliefs of the King and Emperor Charles V.[27] Waterways too often serve purposes other than those dictated by purely economic considerations: in 1834, for instance, Ludwig I of Bavaria was inspired to begin work on the Danube–Main canal partly because Charlemagne had conceived the idea before him.[28]

These striking human additions to the natural scene often figure as motifs in landscape painting, especially that of the seventeenth century; this must be connected with actual trends in transport policy. The special attention paid to bridges was certainly due also to their technical fascination. Bridges across waterways not only provide harmless links between two banks. They are often focuses of military and economic interests; probably no other physical structure has been subject to as much political controversy as the bridge.[29]

It was probably in the Danube School that the bridge first became a special motif in landscape painting. In a drawing of 1540 Augustin Hirschvogel builds up a wild mountain scene with towns and castles inserted into it (illus. 13). Bridges are introduced as conspicuous links: on the left is a simple arched bridge, and from the middle ground on the right a timber bridge, leading to the toll-house at the town wall, describes an elegant curve over the swampy waters. Two years later Wolf Huber took up the theme of masterly bridge-design and to some extent monumentalized it by enclosing the whole of the foreground within the curve of a pile bridge (illus. 14). The emphasis on this triumph over nature is heightened by the sun, which rises at the point where the bridge ends at the city gate.[30] It is hard to imagine that the artist was concerned simply with an interesting motif. For his scene of the parting of Abraham and Lot, Tobias Verhaeght broke up the natural scenery with chasms and ravines, but clearly only in order to make it passable by means of skilfully devised crossings (illus. 15); all sorts of bridges – the scaffolded timber one, the log, the double-arched hump bridge, the distant viaduct by the town – are crossed by people, dogs, oxen, cows and sheep, as though they were to be tested for future load-bearing.[31]

Like Wolf Huber, Altdorfer introduced an element of

unease into the view of a bridge from beneath, as if to draw attention to the often risky labour of bridge-building (illus. 16).[32] An obvious further step was to introduce a moral dimension. This possibly occurs in an engraving by Aegidius Sadeler (illus. 17), in which a wild gorge is spanned by enormous tree-trunks placed beside and across one another to allow human beings to pass over them, as if sleepwalking, with their beasts of burden.[33] In Carl Blechen's *Building of the Devil's Bridge* (illus. 18) all our attention is concentrated on the perfect but perilous triumph over mountain chasms as the new link between the rocky banks of the Reuss is illuminated like a golden bracelet.[34] Such shining bridges reflect the optimism engendered by victory over nature, an optimism that repeatedly inspired the construction of grandiose bridge-heads such those of the Schwabelweis rail bridge of 1859 near Regensburg (illus. 19) and the Elbe Bridge in Hamburg.

In landscape painting prominence was clearly given to motifs whose objective purpose was gaining in political importance; painters became aware of roads as means of conquest, trade, communication and economic development. A drawing by Jacob de Gheyn II from 1598 shows a bridge over a canal (illus. 20). In the foreground the canal takes up the whole width of the sheet; it is then projected into the depth of the picture, where an arched bridge encloses it like a conduit. This bridge is made the dominant motif by the perspectival alignment of the canal and by the sunlight that falls on it.

Well before 1600 the Dutch had taken to planting trees along canals and highways. This was an everyday adaptation of the grand princely avenues that always formed the approaches to stately homes. In the Prater near Vienna an avenue of chestnuts, leading to the 'green pleasure house', was planted as early as 1537. About 1580 Duke August I, Elector of Saxony, no doubt advised by his Dutch gardener, had all the approach roads to Dresden lined with fruit-trees. In Paris various queens laid out the *cours de reine*. After 1647 Maurice of Nassau-Siegen, who was to inspire the promenade 'Unter den Linden' in Berlin, had extensive avenues planted at Cleves and boasted that 'many Dutch people, of high and low estate', came 'simply and solely to see this place'.[35] The few avenues recorded in paintings reflect the socio-political status of the landowners. One picture, attributed to the Flemish artist Sebastiaen Vrancx (illus. 21), relates the avenue to the house

and is careful to show how the rows of trees separate the courtiers strolling at leisure from the peasants at work in the adjacent fields.[36] About 1800 the landscape gardener Sckell observed that only avenues, 'by virtue of their uniquely majestic character, can express the greatness of princes'.[37] Thus Jan van Kessel places the avenue *within* the castle grounds (illus. 22), as the roadside benches indicate. The space taken up by the road in this painting admittedly acquires an importance of its own for various reasons: it is shaded by trees and, in the foreground, the road is blocked by a felled tree; it runs past the castle of Meerdervoort and appears to penetrate into the depth of the picture as if to create a tunnel perspective.[38] Twenty-five years later, van Kessel's friend Meindert Hobbema went a stage further and painted the avenue at Middelharnis (probably at the behest of the town council, which had it planted in 1664) as an autonomous entity (illus. 23).[39] Unlike his precursors, Hobbema frees the avenue from any link with a stately home and does not even relate it to the local church. The avenue, now emancipated, becomes the main theme of a picture. Hobbema's rows of trees, unlike van Kessel's, are an independent formation, to which even the clouds seem to defer. At ground level they divide the wild nature on the left from the enclosed nature on the right; their exceedingly slim trunks project the outline of the avenue into the clouds, which present a peaceful aspect on the left of this dividing line but gather up restlessly on the right. Proudly erect and freed from courtly subservience, the trees line up as witnesses to a cultural achievement of the Dutch republic that has often been emulated.

While the road comes to symbolize the omnipresence of the state, by the twentieth century it seems to have become more threatening to the individual. In 1892 Ferdinand Hodler painted a road strewn with golden leaves that forces its way relentlessly to the evening horizon, where the clouds seem to form a gateway to the inferno (illus. 24). Somewhat later, Munch was to depict a group of girls embraced by the road, the bridge and the riverbank as if by serpents. The road becomes an oppressive place, beset by hostile forces.

Boundaries, bridges and roads are 'land monuments' that are there mainly for practical reasons; they have a function and only indirectly serve a political purpose. This is not true of the monument proper. There are various reasons for placing a

monument in the landscape; however, its presence never serves a utilitarian purpose, but is always intellectually motivated. Many monuments were set up to commemorate events that occurred at certain places.

Commemorative stones linked with particular sites were already common in the High Middle Ages. If a monument was set up at a place where a prince had been assassinated, this was never discernible from a distance. In 1225, for example, Engelbert von Berg, Archbishop of Cologne, was murdered by his nephew in a narrow pass near Gevelsberg. At first a cross was set up at the spot, then ten years later a Cistercian convent. Buildings or monuments marking the sites of sudden deaths were later to be found not only in the country – for instance in the defile at Küssnacht where William Tell is said to have shot Gessler, or by the Starnberger See, where Ludwig II of Bavaria drowned in 1886 – but also in cities: for instance in Paris, on the Boulevard de Montparnasse, near to the Luxembourg Gardens in which Marshal Ney was executed in 1815, or in Berlin, at the bend of the Königsallee, where the foreign minister Walter Rathenau was assassinated in 1922.[40] A prominent murderer might build a church as an act of penance. The Duke of Burgundy, for instance, built the church of Notre Dame at Semur-en-Auxois in 1060 to atone for his involvement in the murder of his father-in-law.[41] As a rule, however, a simple penitential cross sufficed, like the one preserved at Lauingen (illus. 26).[42]

Monuments or buildings commemorating battles are among the rural structures whose sites are predetermined. A famous medieval example is Battle Abbey, built by William the Conqueror to commemorate his victory over the English at Hastings in 1066, while the grandiose project of the Portuguese kings at Batalha never came to fruition. On the battlefield of Welfesholz, where Henry V defeated his princely opponents in 1115, a memorial chapel was built; it is said to have contained a colossal statue of an armed warrior.[43] However, there were more spontaneous local commemorations: 'In 1241 Emperor Frederick II destroyed the castle of Montefortino (in the Campania), built by Pope Gregory IX for his relatives, but he left a half-destroyed tower standing, so that neither the guilt nor the liberation should be forgotten'.[44]

In addition to local monuments such as these, which are found in all ages and in all countries, there are others of a more

personal and private character. In early modern times a growing number of stones or tablets were set up to mark places where rulers were wont to rest, hunt or pray. It also became common to confer political significance on striking natural features by means of inscriptions and appellations such as 'Luther's Beech', 'Bismarck Height' or 'Kaiser Wilhelm Stones'.[45] All the same, it may seem surprising that in 1767 a master-butcher could have set up a costly white monument near Köttweinsdorf to mark the spot where he regained his sight (illus. 25). This showed that the captains and the kings were losing their monopoly on monuments, and to this extent the master-butcher's decision was a political act.[46]

Major monuments owe their siting to a desire to take over beautiful or striking stretches of the landscape for political purposes and to impose a political message on a whole region. If the monument is to be depersonalized and acquire national status, it must be set in surroundings that can uphold such a claim. Kehlheim, Calton Hill near Edinburgh,[47] the 'Deutsches Eck' at Koblenz, the Teutberg in the Teutoburg Forest, Bedloe Island off New York, the Wittekindsberg at the Porta Westfalica on the Weser, the Kyffhäuser Berg, the Heldenberg near Kleinwetzdorf in Lower Austria, the Niederwald near Rüdesheim (illus. 27), Laboe on the Kieler Förde – all these are sites that have placed their scenic attraction at the disposal of a political monument.

In the case of the Kyffhäuser monument (illus. 28), built in 1892–6, it was decided

> without doubt quite deliberately to site it on a hill, remote from any town, so that it would be visible from afar, and to imbue the beholder with a powerful sense of nature, in keeping with the tradition of sensibility and romanticism, so that he would be doubly receptive to the message of the monument. Its location – isolated and commanding, at the 'heart' of the Empire, in open country, removed from everyday life and linked with nature, which was felt to be immune to transience – was meant to ensure its timeless and universal significance.[48]

The chain of Wilhelm Towers – together with the Bismarck Towers, aligned to the west, towards France, the 'traditional enemy' – represents an attempt to fill a whole region with statements of political faith.[49] The result is a political land-

scape, in the most literal sense, which can no longer be divorced from the message conveyed by the monument: the aesthetic qualities of the landscape merely supply the decor.

It is far from easy to imagine how the effect of such monuments was envisaged. When we speak of a 'national monument', we tend to think of its impressing a whole nation and contributing to a national identity. Yet such monuments probably reached the nation only from a distance. In 1814 Leo von Klenze published his design for a peripteral temple as a 'projet de monument à la pacification de l'Europe'. In the same year, for the Congress of Vienna, he published his design for a column to commemorate the Battle of the Nations (1813) at Leipzig. He shows them far removed from any public to which they might have appealed. The temple rises towards the clouds over a stepped base, a seemingly timeless structure indifferent to the landscape. The same is true of Weinbrenner's design for a monument celebrating the Battle of the Nations, and of Schinkel's design (illus. 29) for the Kreuzberg monument: both are detached from the landscape and brought into a dialogue with the sky. The designers of these supposed 'monuments of the peoples' obviously sought out landscapes devoid of people and shunned the chattering classes in the towns.[50] Ludwig I of Bavaria originally wished to have his Walhalla built in the Englischer Garten in Munich. Klenze's paintings of the Walhalla landscape (illus. 30) show long paths leading to the Braunberg near Donaustauf; along these paths people make their way like pilgrims, singly or in groups, on foot or on horseback. For the conferment of new honours Klenze had planned popular festivals, but in everyday life he saw his monument remote and set on high: only after treading the long paths of virtue could one arrive at the mount of virtue.[51]

This kind of monument is characterized by its detachment rather than by any harmonization with the surrounding landscape. For this reason visitors and local inhabitants cannot become indifferent to either.[52] The landscape relates to the monument by deferentially supporting it. The viewer too becomes subservient. He or she is bound to relate to the monument. It is the chief attraction, and usually affords a superb view. This is available after a climb, though it is seldom presented as clearly as from the statue of *Bavaria* on the Theresienwiese in Munich, where we see it through the open

eyes of the statue.[53] When the visitor has reached the heart of the site, the monument is of course no longer visible, but it is only by courtesy of the monument that visually the landscape becomes fully accessible: the revelation of the panorama is a political gesture of grace and favour.

In the course of time the original significance of the monument changes, becomes irrelevant or is lost. The purpose of commemorating a past event, such as a battle, fades from memory. Clear recollection yields more and more to vague expectation: the symbolic function of the monument remains receptive to new associations (though these may have no connection with the impulse that inspired it) and susceptible to new meanings. The political landscape is just as much exposed to current political forces and ideological claims as any other political symbol, except that here the political signs are linked with the idiosyncrasy of the landscape in such a way that the new meanings are coloured by the obvious presence of the natural forces.

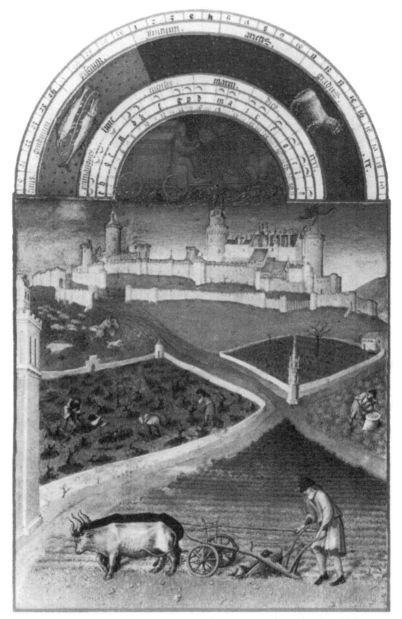

1 Pol, Jean and Herman Limbourg, *March*, miniature from the *Très Riches Heures du Duc de Berri*, c. 1416.

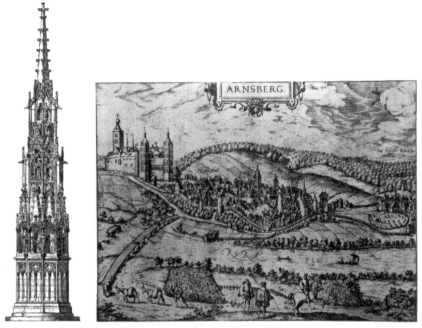

2 The 'Spinnerin am Kreuz', a roadside monument of *c.* 1391–2, built by mayor 'Master Michael' at Wiener Neustadt, near Vienna.

3 A view of Arnsberg, Westphalia, and environs, *c.* 1600.

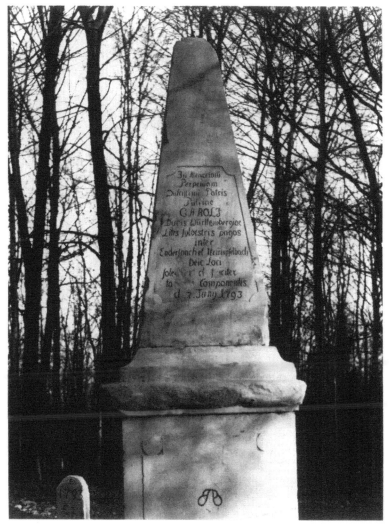

4 A monument to Duke Karl Eugen of Württemberg, 1793, Weinstadt-
Endersbach.

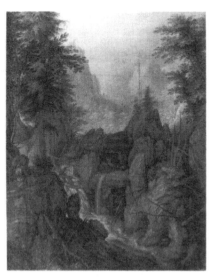

5 Illustration of a secured frontier installation, from Flaminio Croce's *Teatro Militare* (Antwerp, 1617).

6 Roelandt Savary, *Mountain Landscape with Torrent*, 1608.

7 A carved stone dated 1787, marking the boundary of the principality of Mannheim.

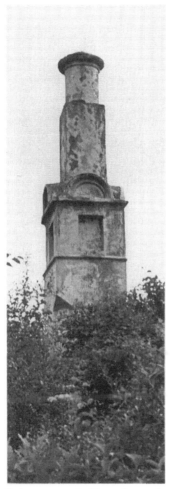

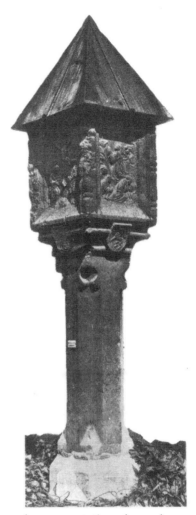

8 An ornamented boundary-column of
c. 1600, near Rain am Lech, Swabia.

9 A commemorative column of 1521,
near the Cistercian foundation at
Raitenhaslach, Bavaria.

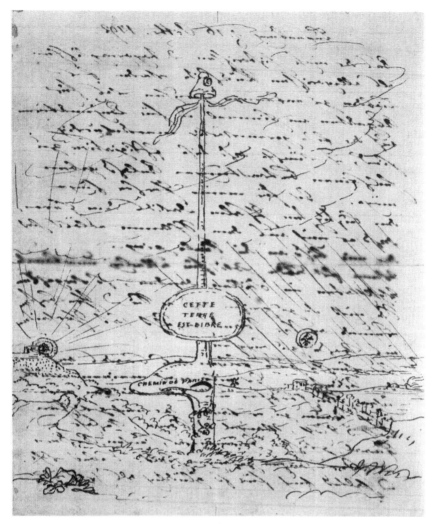

10 J. W. von Goethe, Sketch of an allegorical landscape with a Tree of Liberty, 1792.

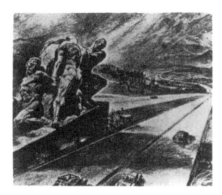

11 Joseph Thorak, design for an autobahn monument, 1938.

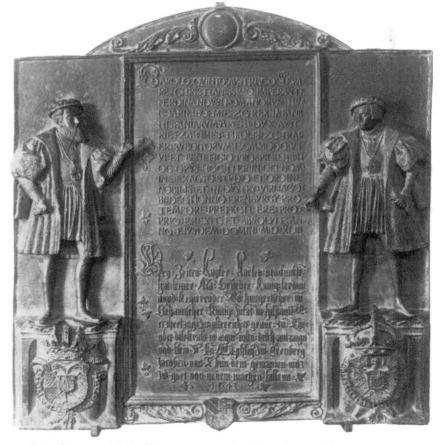

12 V. Arnberger and G. Löffler, commemorative plaque by an Alpine mountain road, dated 1543.

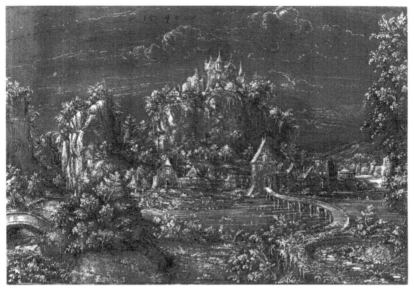

13 Attributed to Augustin Hirschvogel, sketch of a landscape with a town and a bridge, 1540.

14 Wolf Huber, sketch of a city with a large bridge, 1542.

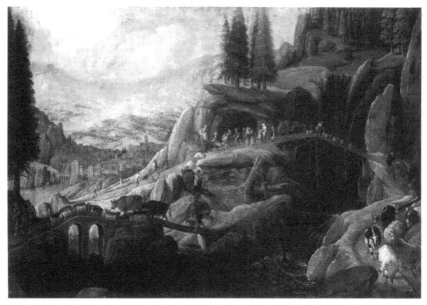

15 Tobias Verhaeght, *Mountain landscape with the Parting of Abraham and Lot,* 1609.

16 Albrecht Altdorfer, *Landscape with a Footbridge*, (?)1516.

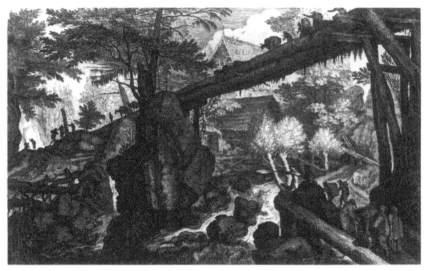

17 Aegidius Sadeler, *Bohemian landscape, c.* 1518–20.

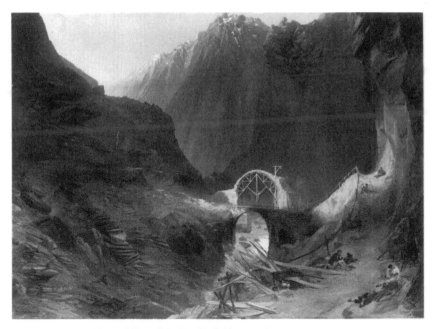

18 Carl Blechen, *The Building of the Devil's Bridge, c.* 1833.

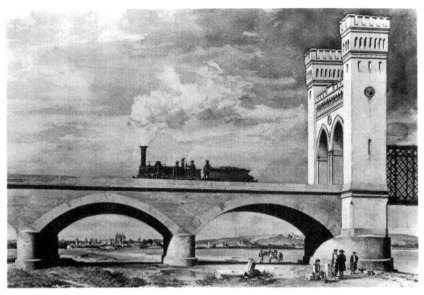

19 A. E. Kirchner, *The Schwabelweis Railway Bridge near Regensburg*, 1859.

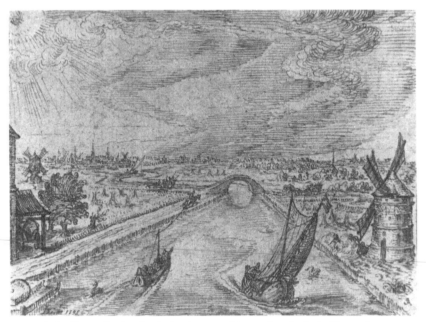

20 Jacob de Gheyn II, sketch of a landscape with canal and windmills, 1598.

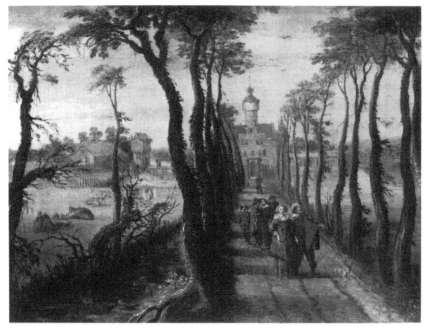

21 Attributed to Sebastiaen Vrancx, *The Avenue*, early 17th century.

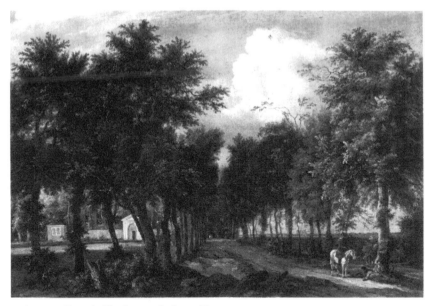

22 Jan van Kessel, *The Avenue*, before 1680.

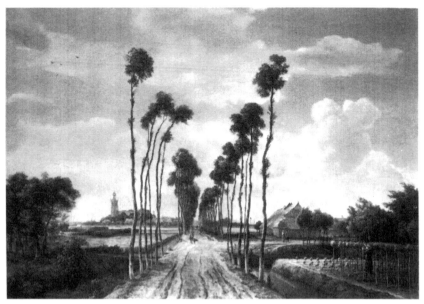

23 Meindert Hobbema, *The Avenue at Middelharnis*, 1689.

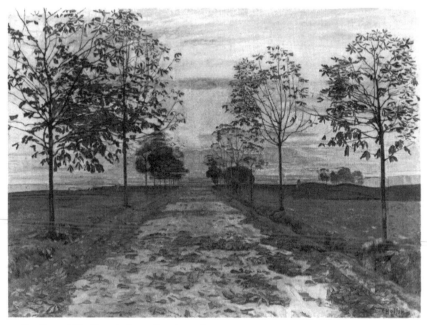

24 Ferdinand Hodler, *Autumn Evening*, 1892.

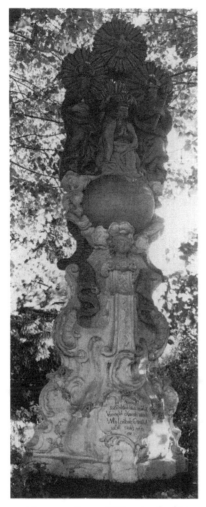

25 Monument near Köttweinsdorf in Franconia, set up by the master-butcher Otto Wich in 1767.

26 Medieval penitential cross at Lauingen, on the road to Birkach, Swabia.

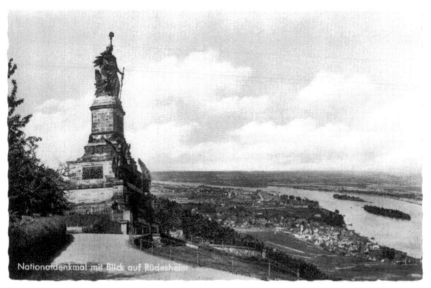

27 Johannes Schilling and Karl Weisbach, The Niederwald monument, 1877–83, above the Rhine at Rüdesheim.

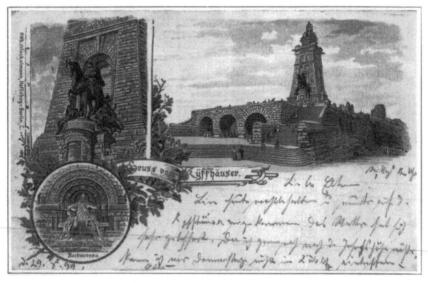

28 A postcard of *c.* 1899 of Bruno Schmitz's design for the 1892–6 Kyffhäuser monument near Bad Frankenhausen, Halle.

29 Karl Friedrich Schinkel, sketch of the design for the Kreuzberg monument, 1823.

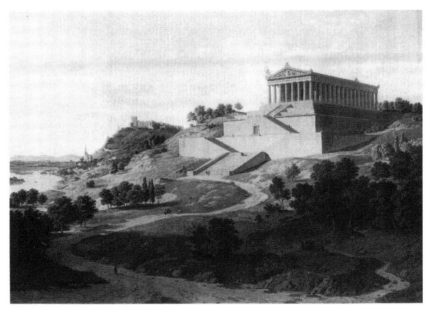

30 Leo von Klenze, *Walhalla*, 1836.

2 Hills and Castles

Many of today's landscape attractions were once military installations. Even the word *boulevard* derives from the German *Bollwerk*, cognate with the English *bulwark*.

Castles have almost come to be regarded as original components of the landscape. Authors of tourist guides are fond of describing castle towers as 'growing' out of the hilltops. In the course of their history these once imposing symbols of a politically occupied landscape have crumbled and become overgrown. Standing in front of them, we are inclined to rhapsodize about their 'blending into the mountain landscape', about their 'natural setting', in which 'mountain and building, nature's handiwork and man's', interfuse and become one.[54]

We climb up to hilltop castles as though they were built to afford us relaxation and a distant view – an impression fostered by picture postcards bearing such legends as 'Burg Gleiberg Restaurant, a popular resort near Giessen'. Scarcely any other type of building has had its original function so thoroughly reinterpreted.

For centuries the owner of the castle surveyed the landscape with suspicious vigilance or imperious pride, but now it is viewed by visitors who come in search of recreation, wishing merely to enjoy the prospect – two views, yesterday's and today's, prompted by quite different interests, from one and the same look-out. We cannot and need not date the change. Among the earliest literary evidence for the concept of 'landscape' (German *Landschaft*) is a passage written by the poet and dramatist Hans Sachs in 1537: 'After this we were both admitted to the tower, from where we saw the landscape far and near, and below the castle a garden in which all manner of small creatures sported'.[55] The narrator reaches this vantage point after running into the woods, in despair of the world, and meeting a woman who leads him to the castle of the Lady Bountiful. Having passed through many rooms, they finally reach the tower. These words certainly cannot be construed as evidence of a new aesthetic appreciation of the castle or the

landscape, but they do record an attempt to gain a view of the surroundings that is unencumbered by military preoccupations. Hans Sachs may still have felt that to visit such a place, to which one had to be 'admitted', amounted to a secret intrusion. Such qualms were obviously not dispelled until the seventeenth and eighteenth centuries, when hardly anyone still visited castles or cared for their upkeep.

Within a historical perspective it might be said that the tourist takeover of the castles was the final triumph of the descendants of those who, over the centuries, had suffered under their yoke.

The view from above is matched by the view from below. This too has changed, even if not as obviously as one might suppose. It is easy to imagine how the citizens of London in 1240 could speak of the Tower as a thorn (*spina*) in the flesh. A text of *c.* 1100 tells us that the owners of castles 'are safer from enemies and have greater power to conquer their equals or oppress those who are weaker'; castles are built 'to force the rebellious and the disloyal to keep the peace'.[56] A monkish chronicle from Padua examines the reasons that drove the power-hungry Ezzelino da Romano (*d.* 1259) to build vast numbers of castles: 'He built castles and fortresses in every town and on every hill, as though he felt constantly beset by enemies. Yet he did all this to demonstrate his power, to intimidate others and cause them to marvel, and so to impress his name on human memory that it would never be forgotten.'[57]

The political view of the castle landscape is seen with almost awesome clarity in Stephan Lochner's *Last Judgment*, which was probably intended for the town hall of Cologne (illus. 31).[58] It assigns the city to heaven and the castle to hell. On the left the blessed enter the city through an open gate; on the right, near a burning castle, the damned are led down below the earth. Eternal peace awaits those who enter the heavenly city, but in the country near the castle, oppression and injustice prevail. Below the castle three monsters are falling on a miser, who is showered with coins. The rapacious ensconced behind the walls of the castles include many Church dignitaries. All are consigned to hell, and so the walls of the castles cease to glow. Seldom has a more harsh judgement been passed on castles.[59] This *Last Judgment* seems like a metaphor for the passing of the age of castles and the dawning of the civic epoch.

Yet despite such unequivocal statements, implying as they do an angry view from below, it is to be assumed that castles were also seen as offering safety and protection. Many citizens grew up in their shadow, and although the struggle against the lord of the castle is a recurrent theme in numerous civic histories, many towns and cities depended on the castle for their trade, their markets and their arts and crafts.

This was a constant feature of the landscape: the castle relying on the city, the city depending on the castle (illus. 32). Many *vedute* show the two interlocking. Not only did the castle recruit its military personnel from the city: both the castle and the city were symbolically depicted as dependent on each other. The castle originally had a communal function as a refuge for the inhabitants of the region – hence the imposts and services they owed to the lord of the castle. It was only gradually, in the early Middle Ages, that this refuge became the residence of a particular family and a seat of power.

The periodic conflicts between the citizens and the lord of the castle may easily incline us to forget the constructive ties between them, which were plainly visible in the shaping of the landscape.

The towns clearly had no trouble in taking over buildings that were supposedly a thorn in the flesh. In the thirteenth century the old castle of Bruges became the seat of the town council. Frescoes in the town hall of Siena show how the cities themselves used fortresses to protect their lands: the part of the fresco in which Lorenzetti depicted the rural peace makes no secret of the fact that this peace would continue to be secured by hill fortresses.[60] And when Italian communes began to devise architectural forms for their town halls, important motifs were borrowed from feudal fortresses.[61] Even today many cities, such as Prague, Würzburg, Ferrara, Nuremberg, Cracow and Marburg, expect the inhabitants to live in the shadow of a castle, yet it is far from clear whether the consciousness of having a castle at their back has fostered a sense of submission, defiance or indifference. If there is anything at all in our theories of perception, they should give us some indication as to whether or not it matters that someone has grown up in the shadow of a castle. We may provisionally assume that the castle can also be perceived as a protective super-ego. From classical times it had often been

said that the prince's best fortress was the love of his people. But in emblems the converse could also be asserted: that the prince's loyalty and solicitude were the people's safest stronghold.[62] Pictures of the Virgin Mary often include a castle in the background, and even in the nineteenth century some churches were built in the form of a castle: God was 'a safe stronghold', with a dual role as the protector of the faithful and the lord whom they must fear. One might discern a psychological interpretation of the castle in a portrait of a woman by Altobello Melone (illus. 33). On a level with her head a large castle extends over a broad hilltop, doubtless indicating her inner steadfastness.[63]

Whatever relations may have obtained with the powers that be at any given time, it is true to say that castles, 'through their physical distance from the subjects, also created and signalled a social distance'.[64] As in all relations with authority, there was much scope for local and temporal variants. Many owners of castles evidently considered this social distance necessary for purposes of representation, even when it had become militarily redundant. Others built themselves 'open houses' in the country or relatively unprotected palaces in the city. In the late Middle Ages, then, the rural castle could be viewed from various angles.

It must be of some significance that when painters were required to replace or vary the gold backgrounds of altarpieces by adding landscapes, they often set fantastic castles on mountain chains or individual summits (illus. 34, 35). In Trecento painting there was no dearth of bare mountains, but castles were almost unknown.[65] Later, however, when castles had virtually lost any defensive role, they were often placed on the hilltops that rose towards the gold background, as if to defend the experience of reality against the transcendent claim of the background – as though the old castles could now serve only as a shield against the old heaven. In northern Italy, with Mantegna and his followers, then in classical Venetian painting, and in German painting too, until well into the sixteenth century, castle-topped hills take on numerous exotic forms. On windy heights they rise in solitary prime against blue or clouded skies. The rock formations below become ever more exuberant. The castles have hardly any contact with the earth: only remote, tortuous paths lead up the mountainsides. True, in the fifteenth century fortresses were still being built on high

ground, but Francesco di Giorgio's Rocca in San Leo is unique (illus. 37). The invention of gunpowder finally forced the castles down into the plain, as defence now depended less on their altitude than on the thickness of their walls. The lofty hill-fortresses cannot fail to create the impression that, as the sense of reality revived, so did the pleasure afforded by the castles – which had by now become impractical, unreal.

These late depictions of castles suggest that a certain satisfaction was derived from the thought that these grand seats of power had become ineffectual. Stripped of any real function, they were now merely decorative motifs, to be used as ornamental fillers.

Viewing the castles in the topographical setting to which the artists assign them, we are struck by yet another feature. In the work of Mantegna – and even more clearly in that of the Ferrarese painters and those working north of the Alps – the castles are set in landscapes that, if not rocky wildernesses, are at least rugged, remote and forbidding (illus. 36, 38). What paths there are follow arduous courses, and the trees are often as bizarre as the rocks – riven and fragmented, suggesting a somewhat disturbed sense of nature. It has been remarked that 'in the Middle Ages the city was seen as the realm of law and order, as opposed to the lawless open landscape'. In the Arena Chapel, therefore, Giotto depicted Injustice as a tyrant 'sitting outside the city gate, ruling over a wilderness in which brigands indulge in robbery and murder'.[66] The 'free' land-scape is inhospitable, dangerous, almost inaccessible, and the castles seem part of this hostile world. The humanists' songs in praise of the *loci amoeni*, if not mere literary exercises, amount to little more than wishful thinking.

When the Limbourg brothers were charged with illustrating the Duke of Berry's Books of Hours, they responded to this well-founded view of a hostile natural world with a concept that must have accorded with their patron's dearest wishes. There are two political elements in the pictures that make up the cycle of months in the *Très Riches Heures*: the castles and the rural activities associated with them, varying from season to season. The illuminations by the Limbourgs allow the Duke to see both from without, to feel that he is outside his castle. Castle and countryside interlock, so to speak: in the fore-ground the countryside, looking up; in the background the castle of Lusignan, looking down (illus. 1). The illuminations

do everything to interrelate them, to make the one appear as the natural attribute of the other. The castle determines how the surrounding land is parcelled and tilled. A road runs from its front gate and intersects with another at a right-angle. The intersection is marked by the montjoy, a shaft with a balda-chin and figures of saints. Coming from the castle and turning right at this monument, one faces a tower that seems to guard the peace and watch over all that goes on. The roads divide the land into four equal fields, partly walled, in each of which an activity proper to the month of March takes place. The chief event is the trimming of the vines. In another field a peasant riddles corn into a sack. The pious Duke could see that everything was centred upon his castle, how sensibly all was ordered, how safely the land could be tilled under the protection of his castles and fortresses, which could bring order to the land if only the land acknowledged that it was subject to his rule.

Here we have the concept of peaceful, well-ordered land-use, involving a rational division of labour and secured by a central authority that governs the whole. The Limbourgs also try to bring out features of the castle's domestic comfort by means of sky-blue roofs and smoke rising from the chimneys. The message is unequivocally optimistic. True, the winged serpent of the fairy Mélusine hovers above the capped tower; she has still has to guard the castle, because governmental authority for the area is far from wholly secured through the castle's own means. Yet the general sense is clear: the land must be tilled and made productive through the agency of the castle, which is no longer just a guarantor of security, but a great storehouse into which everything produced through the rational exploitation of the land is garnered.

In the Low Countries this seigneurial concept of the relation between castle and country gave credibility to one of the most notable achievements of landscape painting, the panoramic landscape. This was represented by van Eyck, probably at first in his intimate book miniatures and later in the backgrounds of his altarpieces. On the panel painted for Nicolas Rolin, Duke Philip the Good's chancellor, he even placed two figures in the background, standing by an opening in the battlements, in order to convey the new landscape dimension to the viewer (illus. 39). One figure has stood aside to allow the other to see the panorama through the embrasure. The latter is trying to

gauge his distance from the ground, as any child might do. Meanwhile, in the foreground, probably in a palace chapel, the chancellor is at prayer. It must have accorded with the utopian dreams of this rich and powerful individual that an open palace hall should look out on an open landscape and that the Limbourgs' strict attribution of the landscape to the castle should be taken a stage further. That the boundaries between city and country, between near and far, should become transparent, that they should be kept flexible and passable in both directions, so that a hint from the palace would find an echo in the arch of a distant bridge – this dream of the merchant class coincided with the administrative conception of a unified state in which all particularist interests were levelled.

Castles, symbolizing the particularist counterforces of feudalism, blocked any such perspective. Even painters began to pay less and less attention to them, or if they did, they depicted them as ruinous and ivy-clad. Such castles merely lent a picturesque touch to the landscape. Occasionally a castle might appear as a stately home, an image of wealth and pretension, if juxtaposed to a lowly cottage in the plain, betokening selfless modesty.[67] Yet in eighteenth-century British landscape painting – in the work of Richard Wilson, for instance – crumbling castles might still symbolize ancient Welsh liberty, destroyed by the conquering English.[68]

In the wake of the French Revolution there was a new nostalgia for knightly castles and a longing for more settled conditions. The view from the castle was transfigured and could now evoke a feeling of harmony between the country and its rulers. Much was done to gratify such romantic longings: old castles were restored and extended; new castles – ideal ancestral homes – were built (illus. 40). Klenze still saw the castle ruins at Donaustauf, near his Walhalla, as a 'symbol of defeated feudalism', but the castles built by Ludwig I of Bavaria were dedicated to the enjoyment of the landscape; they were to be looked at and looked out from, so that the old national order could be relived.[69] This longing for harmony, this desire to gaze out on to the landscape from the heights, gave birth to the chain of Bismarck Towers and Wilhelm Towers. And in the years that followed, many youthful ramblers and nature-lovers were inspired by similar aims. Castle tourism remains political even today, when the political past of the castles has been entirely suppressed.

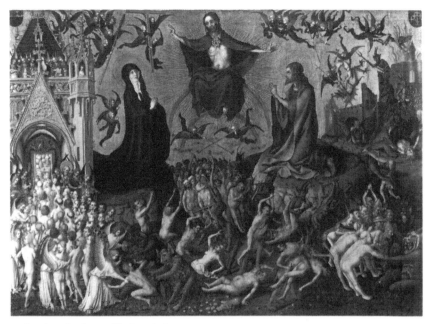

31 Stephan Lochner, *The Last Judgment*, c. 1435.

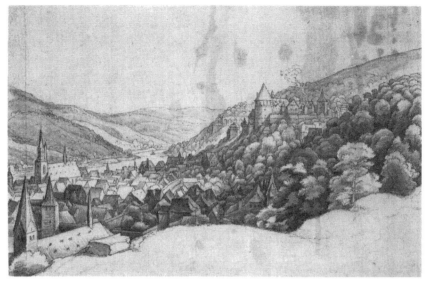

32 Mathäus Merian, sketch of Heidelberg, 1619/20.

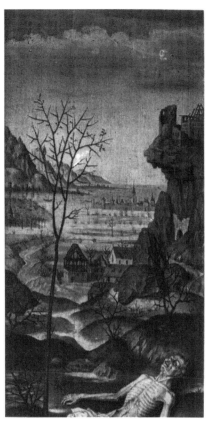

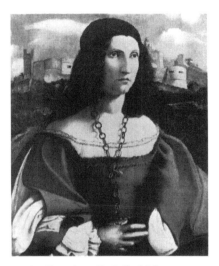

33 Attributed to Altobello Melone, *Portrait of a Woman*, c. 1510.

34 Upper Rhenish Master, detail of the rocky background to an *Allegory of Death*, c. 1480.

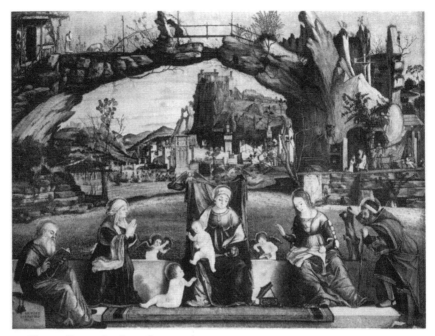

35 Vittore Carpaccio, *Sacra Conversazione, c.* 1500.

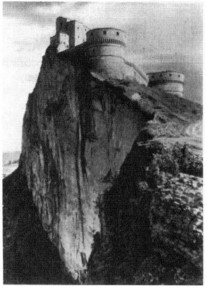

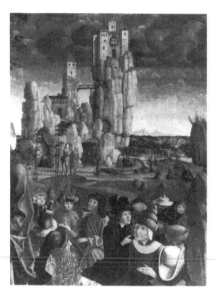

36 Andrea Mantegna, detail of the rocky background in a fresco of *c.* 1460 in the Camera degli Sposi of the Palazzo Ducale, Mantua.

37 Part of the medieval fortress of San Leo in the Marche, restored *c.* 1480 by Francesco di Giorgio.

38 Michael Pacher, detail of the rocky background to the *St Wolfgang Altar,* *c.* 1471–81.

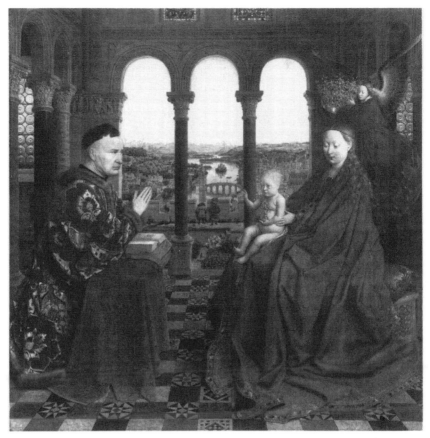

39 Jan van Eyck, *Virgin and Child with Nicolas Rolin*, c. 1436.

40 Liechtenstein Castle.

3 From Battlefield to War Landscape

One of the earliest functions of the pure landscape picture seems to have been to provide evidence of ownership, like an entry in a land register. In the fortress of Caprarola, Lazio, and in the courtyard of the Palazzo della Signoria in Florence, the painting was displayed as a notice of title. In the castle of Stuttgart in the second half of the sixteenth century pictures were painted of the prince's properties; this indicated his 'attitude to ownership and his wish to compile an inventory'.[70] In eighteenth-century England, one of the arguments used against topographical landscape art was that it reflected only the paltry proprietory pride of the landowner.[71]

The use of a cycle of landscape paintings as a means of surveying one's holdings naturally implied a realization that they had to be managed, cultivated and exploited. The landscape was committed to memory, as it were. The ruler had to know it, 'oversee' it and ensure that it remained disposable, beyond the dates on which taxes and services fell due; he probably also had to know how and at what points it could be defended. Public property is often acquired through conquest; there may thus be a relationship between landscape paintings and the conqueror, between the memory of his deeds and the record of their outcome. In 1621 the highly successful general Ambrogio Spinola, a native of Genoa who spent most of his life in the service of the Spanish crown, had his engraved portrait ringed, as if by a chain of trophies, by depictions of 58 castles, towns and fortresses he had conquered (illus. 41).[72]

Though wars have always been fought for land, it was only gradually that the landscape came to be envisaged as a field of military operations.

So long as war was regarded as a personal contest, a privilege restricted to the noble and powerful, it centred chiefly on interpersonal disputes. The contenders sought level ground on which they could meet in open combat. In paintings the contest is raised above eye-level and appears as a meeting between individuals (illus. 42). The participants are

equipped with armour, shields and various weapons, but seek a meeting in direct combat. To take advantage of topographical features, vegetation or the lie of the land would be to resort to deceit and cowardly cunning.[73] Attacks could always be mounted against the country and its inhabitants, but these fell outside the rules of war. Within the framework of a feud the destruction of woods, gardens or crops – what was known as 'robbery and burning' – were legitimate punitive actions, but warfare proper was concerned with questions of right, and these were decided, should no other regular means avail, by man-to-man combat.[74]

In the field of tactics attention was naturally paid to topographical features. This was true at Thermopylae no less than at Hastings in 1066, when there was no question of Harold

> advancing against the enemy in the plain: his troops would have immediately been scattered by the Norman horsemen. King Harold therefore chose a position on a broad hill, where his army was fairly densely disposed. However, the great advantage of this position was that there were fairly steep slopes to the rear, and in the middle a narrow isthmus leading directly into a wood. If defeated, the Anglo-Saxons could descend the slopes on foot and flee into the wood, and the horsemen could not easily pursue them.[75]

According to the Italian military theorist Aegidius a Columnis (d. 1316), a position on somewhat higher ground was one of the twelve things to be considered in connection with a battle.[76] Yet this did not amount to a strategic appreciation of the landscape as offering a chance of victory over the terrain, rather than over the enemy; the terrain was not yet identified with the enemy. War remained a contest between privileged individuals.

The advent of firearms forced the opponents apart. Suits of armour no longer gave adequate protection against increasingly effective weapons: 'landscape protection' was needed, in the form of trees, ditches, woods or walls. This meant that the positions of the combatants and the possible advantages afforded by the terrain became new factors in the technique of warfare. Yet it was a long time before the new weapons became so efficient as to give rise to a new perception of warfare. Fabricio Colonna tells us that in 1503, at the battle of Cerignola between the Spanish and the French,

it was not the bravery of the troops or the valour of the commander that carried the day, but the small dyke and trench that the Spaniards had occupied with marksmen before their front line. From this position the infantry then went over to the offensive. The obstacle in the front line – the effect of the marksmen – the assault or the absence of an assault on the obstacle or from it: these are from now on the basic colours in paintings of battles.[77]

Such trenches were clearly so important that the battle of the White Mountain in 1620 is said to have been lost 'because the necessary spades were not brought soon enough'.[78]

Yet, however important the exploitation of the landscape may have been on occasion, there was no general appreciation of its military significance. In the sixteenth century, and for a long time afterwards, artists went on painting battle scenes as though they were recording encounters between heroes of antiquity. This archaic view of war is presented by Vasari in his drawing (c. 1555) of the battle of San Secondo (illus. 43). Here the combatants are presented in attitudes familiar from ancient sculptures. The antiquated nature of such a scene becomes clear from a remark made by a contemporary of Vasari, the French Marshal Tavannes, who said that whereas formerly 500 horsemen would have fought for hours and at most ten would have fallen, 'now it is all over in an hour'.[79] Rubens too adopted the classical mode in depicting a modern battle – that fought by Henri IV of France at Ivry in 1590 – as though it were an encounter between Achilles and Hector (illus. 42). War is reduced almost to a heroic duel between the leaders, even though in this very battle the cavalry made military history by using 'pistol-horsemen' for the first time.[80] These 'mythicized' wars were intended for the halls of fame; reality was wholly overlaid by wishful thinking.

When more realistic pictures were required, attention was paid to the new military structures. Whereas in medieval pictures a battle is shown as a set of fierce single combats, the emphasis now shifts to the massed forces deployed in modern war.[81] In Altdorfer's *Battle of Alexander* the armies are treated in meticulous detail (illus. 44). Through the use of massed forces the entire battle blends into a cosmic panorama of landscape and sky, in which oriental and occidental features are juxtaposed. Altdorfer enhances the effect of Alexander's

defeat of the Persians by means of a political skyscape.[82] When his contemporaries had to draw battles for Emperor Maximilian, they showed the troops equipped with spears and had them set on one another with no significant topographical background. Spanish artists then drew lances packed together in *tercios* or rectangular blocks: the soldiers were formed up like a living fortress and so could hardly adapt themselves to the terrain. This can be seen quite clearly in a work on military technique by Orlers and Van Haesten (1612): it shows a battle taking place among numerous hills, but no use is made of any one of them (illus. 45); rather, the troops are disposed in such a way that they can always advance freely against one another.

In as much as the attack was no longer directed simply against the opponent himself, but against his supply lines, his quarters and his surroundings, artists were able to render important services to the strategist. Barthel Behaim's drawing of the Turkish camp outside Vienna, a drawing said to have been made in 1529 from an observation post on the tower of St Stephen's cathedral, certainly provided a useful view of the enemy's quarters.[83] In 1548 King Edward VI of England was warned that a painter called Nicholas had given the French monarch, Henri II, 'pictures of all the havens in England', with the help of which the French 'may land their men that go into Scotland easily'.[84] As potential 'picture reporters', painters travelling abroad might easily be suspected of being in the service of a foreign power. Right up to the Great War of 1914–18 artists continued to accompany the armies, working on up-to-date reports or preparing subsequent battle pictures.

For tactics in the field it was sometimes possible to draw on the artists' expertise. About 1500 Pedro de Aponte, a painter to the court in Aragon, is said to have invented the trick of deceiving the enemy by the use of painted papier mâché walls.[85] In *Macbeth* the advancing wood of Birnam is not intended to serve as camouflage, but as Malcolm says (Act V, scene: iv), to 'shadow the numbers of our host'.

The artists themselves boasted of their new military importance, as though it conferred nobility on them.[86] Francisco de Hollanda reports Michelangelo as saying:

What greater service can a brave leader perform for raw recruits and inexperienced soldiers than to show them,

before the battle, a picture of the town they are to storm or the river, hills and country houses they are to march past the following day? ... I also believe that Alexander the Great may often have made use of the art of Apelles in his great enterprises if he himself was unable to draw. Likewise we see from the commentaries of Julius Caesar what important services were rendered by the art of drawing, practised by an able man in his army. . . . I would even assert that no modern general, commanding large masses of men, can ever perform great deeds and win military fame if he does not practise or understand the art of drawing and painting.[87]

Drawing makes it possible to anticipate conditions and situations and to make dispositions in the event of war. The landscape becomes a kind of chessboard: to the strategist it is simply and solely a field of operations, in which special features are of tactical importance. The artist's role in all this is to produce not so much a faithful depiction of nature as an analytical breakdown of it. Perspective is by no means the most important means he has to use: distances, structures, and special features tend to matter more; it may well be that a two-dimensional outline drawing is more useful than a three-dimensional projection involving perspective.

The co-ordination of masses of men with space and time in a visual medium played a part in theoretical military training. Fleming's *Teutscher Soldat*, 1726 (illus. 46), shows the hall of a military school in which officers move around among maps – and probably drawings – as if in a gallery. On the narrow wall hangs a large map with a landscape containing the ground-plan of a fortress and battlefields. Before it an officer with a baton lectures to three students. Between the windows, on the wall to the left, hang drawings of weapons, plans of fortresses and orders of battle. In this purely theoretical milieu the landscape becomes a tableau, the elements of which have to be spelt out and memorized. 'The geographical area in which the armies operated resembled a system of co-ordinates made up of assembly points, stages of march, positions, stores and lines of communication, with fortresses as key points' (illus. 47).[88]

If this system was to remain effective, the commanders had to withdraw from the heat of the battle in order to gain the

detachment that was necessary for making operational decisions. 'The terrain', said Frederick the Great, 'is the first oracle one must consult. From it one can divine the enemy's dispositions'.[89]

When a battle is in progress, or is about to begin, the commander surveys the landscape very much as if he were lecturing in front of a wall-map. Landscape occurs in sixteenth-century portraits of military leaders such as Tintoretto's of Pietro Pisani (illus. 49), but only attributively.[90] The theatre of operations appears as a background scroll; the commander is not yet observed acting in and above the landscape. As we see in numerous *allocutio* pictures (illus. 48), the old pattern of man-to-man confrontation is retained. Then, in the seventeenth century, the commander takes up a position above the fighting, from which he can survey the whole of the action. Having moved into such a position, the ruler, or his lieutenant, ceases to be a combatant; he no longer shares the lot of his soldiers, who now constitute a war-machine in a theatre that needs a director. The director is the star, whose name is known to everyone – Alessandro Farnese, Juan d'Austria, Wallenstein, Spinola, Tilly, Turenne, Prince Eugen. On the battlefield, meanwhile, the mobile, anonymous, well-drilled masses fight it out. The pictures now evolve stereotyped formulas that reflect the mutual relations between the brilliant commander, issuing orders and surveying the field from a safe distance, and the mass of the combatants, performing like clockwork in precise formations.

In 1615 Guillaume Baudart made a series of engravings to illustrate his account of the wars of the princes of Nassau. In these the commander appears on horseback, remote from the battle, but decisively influencing it (illus. 50),[91] a situation that must have been familiar to Velázquez when he was called on to depict Duke Olivarez – who, according to Carl Justi, never smelt powder – operating from a similar position of command.[92]

The placing of the commander in front of the landscape, as on a stage, probably spread to Spain from the Low Countries; at all events, the Prado still possesses Peeter Snayers's great panoramas, one of which shows Isabella Clara Eugenia inspecting the measures taken for the siege of Breda (illus. 51).[93] Standing in the foreground with her retinue, she surveys the landscape, which in the middle ground seems to

merge into a cartographic projection such as Callot had drawn for the same siege in 1626.[94] This treatment recurs in the Low Countries in 1706: after defeating the French at Ramillies, the Duke of Marlborough, clad in Roman armour, is shown riding over the fallen figures of Envy and Falsehood towards the shore of a waterway, a scene that, at its margin, dissolves into a map of the estuary of the Schelde (illus. 52).[95] Obviously the different planes of reality are fused to produce a superior view of the events: in the background the victorious troops assembling in the landscape, then the allegorically clad figure of the mounted Duke, affecting the air of Marcus Aurelius on the Capitol and pointing with his baton at the adjacent map. Nothing could bring out more forcefully the extent to which landscape is transformed into a theatre in which cabinets have their wargames enacted. To the commander, however, the landscape is simply a map given concrete form, just as the map is a landscape converted for operational use.[96] This decorative mixture of different levels of representation matches the term used to designate the whole – le théâtre de la guerre. When H. Löschenkohl shows Emperor Joseph II and his generals inspecting a battlefield, the lines and groupings of the troops transform the landscape almost into an ornamental construct.[97] Horace Vernet shows Napoleon in the same equestrian pose at the battle of Wagram, handing a document to a messenger for transmission (illus. 53).[98] On the site of the battle of Jena a 'Napoleon stone' marks the high ground from which the Emperor directed the struggle. For future commanders a superior vantage-point of this kind remained indispensable. Anton von Werner in 1884 placed Moltke at Sedan in this position of superior isolation (illus. 54), which had already been assigned to Garibaldi in 1861 (illus. 55). A lonely figure in his costume of a revolutionary, Garibaldi gazes down into the plain from the heights, prefiguring the gaze of ramblers and tourists and taking in the view that makes such a vantage-point so popular today.[99]

Quite different from the view of the strategist and the commander, to whom the military landscape is simply a field of operations, is that of the combatant. So long as he was a disciplined cog in a machine, he did not need to identify himself with the landscape. The soldier did not melt into the landscape until he began to operate from within it. Fleming's Teutscher Soldat of 1726 shows a landscape after a battle,

strewn with bodies of men and horses (illus. 56). The dead and injured have hardly any contact with the earth, which seems to have remained undamaged. At least the engraver does not trouble to show the ravages of war: there are no ditches or trenches to be seen. This changed as soon as the effect of firearms forced the soldier to dig himself into the landscape and become part of it. In the second half of the eighteenth century,

> systematic rules began to be drawn up as to how the soldiers could protect themselves quickly and at little cost.... Obstacles and barriers must hamper the enemy's advance. These included walls, the ditch and its sides, the water in the ditch, flooded areas, barriers, palisades and stakes.... The simplest form of cover was an earth-wall or embankment, known as breastwork; its top part was called the crown.[100]

The *tirailleurs* of the Revolutionary Wars put an end to line tactics; an overall view of the battle was no longer possible, as the soldiers, impelled by nationalistic fervour – one might almost say by blind fury – no longer behaved according to rules that had been learnt, though they were skilled at exploiting the terrain and shooting from cover. Guerrilla tactics, which became important in the Peninsular War and the Franco-Prussian war of 1870–71 (*guerrilla*, as the diminutive of Spanish *guerra*, meant 'little war') drew on knowledge of the landscape in a manner that Field-Marshal Count Radetzky had already described in 1852: 'The more broken up the terrain is and the harder it is to survey, the easier it is to mount surprise attacks, but in open country ditches, hedges, bushes or high-standing corn are also suitable.'[101]

It was not only the character of the 'popular wars', and the military fervour they engendered, that gave warfare a new aspect, but also the new symbiosis of the soldiers and their tactics with the landscape. This change was registered by artists, who no longer confined themselves to depicting the battles themselves, but learned to observe the scenery after the battle. In Goya's *Disasters of War*, etched between 1810 and 1815, there are scenes in which corpses blend with the landscape; nature becomes a compassionate witness of the terror and man shares the fate of the landscape.

Anyone who could foresee the development of armaments

in the present century must have realized that wars would be fought not only for land – as they always had been – but in and against the landscape. Even before the mechanized battles of the Great War, certain allegories of war pointed in this direction. Though Franz von Stuck's war allegory of 1894 was no doubt largely symbolic in intention (illus. 57), the nocturnal landscape of corpses, in which a young horseman remains motionless, is evidently informed by a sense of nature's participation in the combat.[102] There is something enigmatic about Ludwig Meidner's 'apocalyptic landscapes' of c. 1912, which show nature convulsed in cataclysmic turmoil (illus. 58). There may be no human beings in them, but human beings too could be drawn into the chaos.[103] Even Fritz Erler, who usually inclined to a heroic view of human beings, nevertheless correctly assessed the first indications of the direction the Great War would take in his *Death of Ypres* (1914) when he 'married' (as might have been said at the time) the bodies of the young foreign soldiers with the earth (illus. 61); however, the fact that a dry branch, with a strip of clothing hanging from it, protrudes into the picture, as if grieving, points to a sense of nature's involvement.[104]

Because the soldier was increasingly forced to hide in the ground in order to protect himself from the efficiency of the weapons and attacks from the air, man-to-man combat gave way to trench warfare, the battle of the mud. And at sea the submarines made whole areas of the struggle invisible.

As a result of these shifts the soldier came more and more to merge with the landscape. In India in the 1850s the British adopted khaki uniforms, supposedly matching the colour of the earth, so that the soldiers outwardly resembled it. This practice was to be widely followed (illus. 59). In the Great War the Germans adopted field-grey uniforms and spikeless helmets, while camouflage covers, designed by artists and first used in France, were draped over the big guns. In the Second World War camouflage jackets came into general use.[105] War could thus appear as an artificial nature drama; accordingly the war picture became a landscape picture. At the beginning of the Great War, Paul Klee, a Swiss, drew attention to this new phenomenon in the work *The War that Devastates the Land* (illus. 62). No human victims appear in it – only the fragmented landscape shooting up into new shapes. The landscape seems to be the playground of destructive

forces that deform and disfigure it, rob it of its identity and transform it into quite new forms of reality.[106] If the individual soldier still has a role to play, he is made more and more to resemble the soil. This perception is taken to the extreme in Otto Dix's war pictures, where the soldiers, whether alive or dead, are lodged in the ground, like earth-creatures exposed to cosmic violence (illus. 63).[107]

The Second World War hardly lent itself to artistic treatment. Perhaps the universal consequences of war in our own century are best represented in a landscape dimension.[108]

The war cemeteries that are scattered throughout Europe impose on the landscape the pattern of serial death. In 1917 the landscape architect Willi Lange proposed that every fallen German soldier should be honoured by the planting of an oak. It was only in 1932 that this proposal came close to fruition. An official competition was advertized for a 'national grove of honour' in the woods near Bad Berka in Thuringia, between Tannroda and Blankenhain. It attracted 1828 entries, but the National Socialists put an end to the project.[109] They probably still clung to the illusion of the heroic individual death. A more realistic reflection of the trend of modern war is probably to be seen in Hitler's 'scorched earth' policy. This trend culminates in nuclear war (illus. 64), in which not only individual human beings – the inhabitants of a region or a nation – are killed, but their habitat too, the plants, the soil, the air.

In those pictures that venture to present an image of atomic war there is no place for human beings: gorgeous multi-coloured mushroom clouds rise into the sky, but only the good Lord can see and appreciate this magnificent landscape.

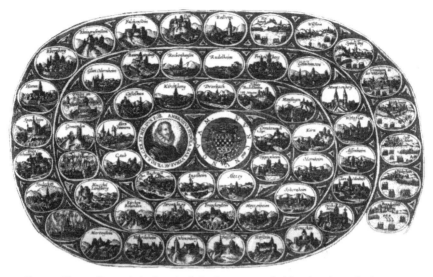

41 George Kress, General Ambrogio Spinola, surrounded by the places he has captured, 1621.

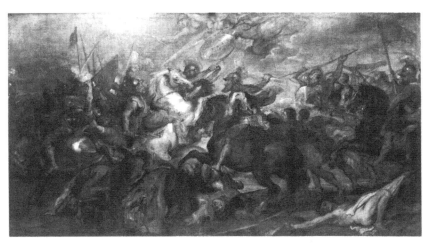

42 Peter Paul Rubens, *Henri IV of France at the Battle of Ivry (1590)*, c. 1628–31.

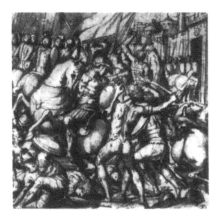

43 Giorgo Vasari, drawing of the Battle of San Secondo, c. 1555.

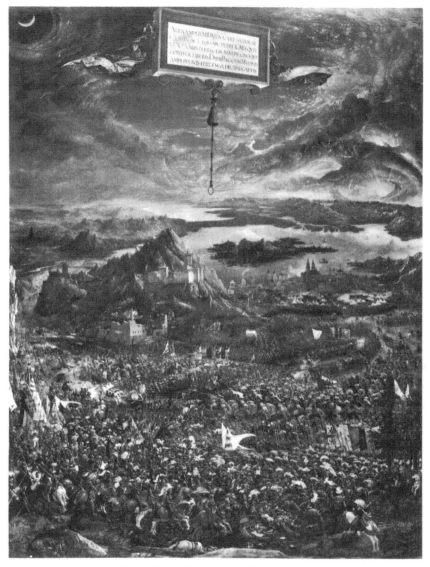

44 Albrecht Altdorfer, *The Battle of Alexander and Darius at Issus in 334 BC*, 1529.

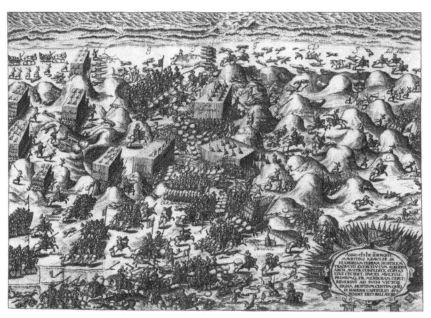

45 A battle of 1602 between Maurice of Nassau and Duke Albrecht of Austria, from
Orlers and Van Haesten's *Description* . . . of 1612.

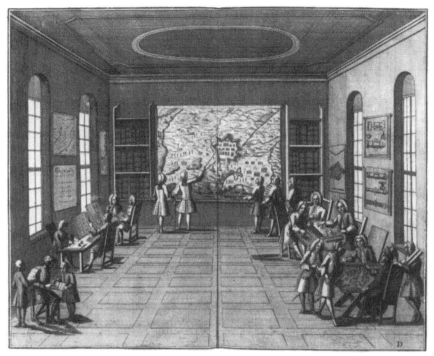

46 An officers' school, from Fleming's *Teutscher Soldat* of 1726.

47 The strategic situation at the Battle of Malplaquet (1709), from von Sachsen's *Art de la Guerre* of 1758.

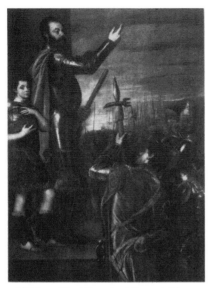

48 Titian, *The Allocutio of General del Vasto, c.* 1540.

49 Jacopo Tintoretto, *Portrait of General Pietro Pisani c.* 1560.

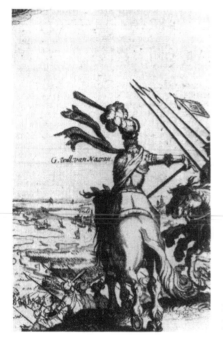

50 William of Nassau on horseback at the Siege of Groningen, from a Dutch history of 1616.

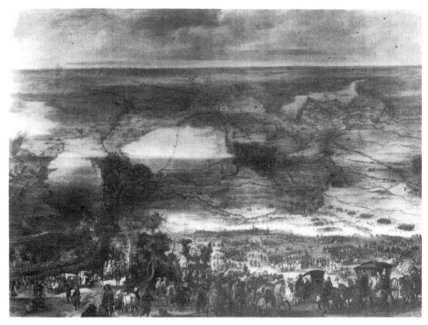

51 Peeter Snayers, *The Stadholder Isabella at the Siege of Breda*, c. 1630.

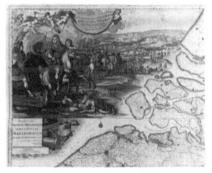

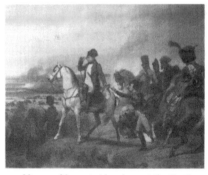

52 The Duke of Marlborough before the theatre of operations in the Low Countries, after 1706.

53 Horace Vernet, *Napoleon at the Battle of Wagram (1809)*, 1836.

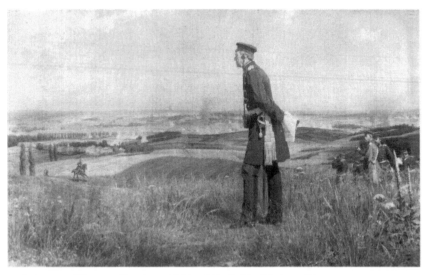

54 Anton von Werner, *Count von Moltke at the Battle of Sedan*, 1884.

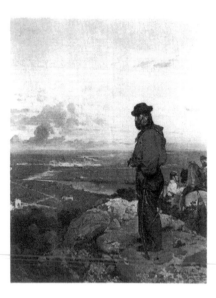

55 Girolamo Induno, *Garibaldi before Capua*, 1861.

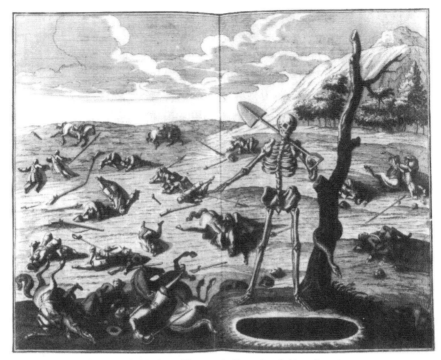

56 Engraving of a battlefield, from Fleming's *Teutscher Soldat* of 1726.

57 Franz von Stuck, *War*, 1894.

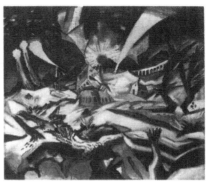

58 Ludwig Meidner, *Apocalyptic Landscape*, c. 1912.

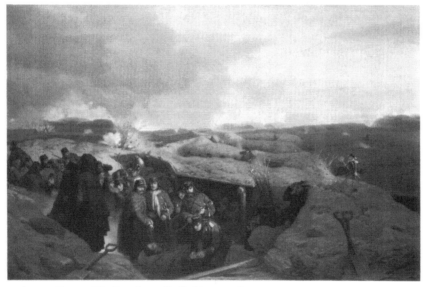

59 Jørgen Sonne, *The Trenches at Dybbøl (1864)*, 1871.

60 Paul Nash, *Battle of Germany*, 1944. 61 Fritz Erler, *Death of Ypres*, 1915.

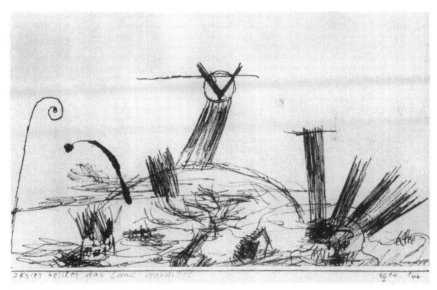

62 Paul Klee, *The War that Devastates the Land*, 1914.

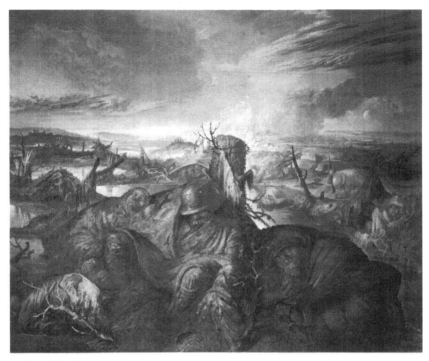

63 Otto Dix, *Flanders*, 1934–6.

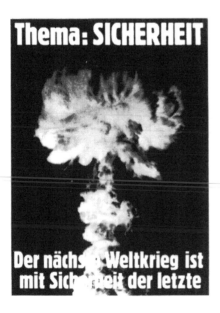

64 *Theme: CERTAINTY. The next world war will certainly be the last one*, a 1981 poster by Klaus Staeck.

4 Nature's Freedom as Political Freedom

'When founding a city, one should choose a location where the beauty of the landscape will give pleasure to the inhabitants', asserted St Thomas Aquinas:

> For they are unlikely to leave a pleasant place, and it is equally unlikely that inhabitants will flock to a place devoid of all natural charm, for people cannot live for long without a certain measure of beauty. The site should be extensive, with level fields and trees, and hills nearby to afford a pleasing prospect; the landscape should be fringed by woodlands, and everywhere there should be streams flowing through it. However, because excessive amenity inclines man to immoderate pleasure, which is extremely harmful to the state, amenity must be enjoyed in moderation.

The appreciation of the beauty of the landscape that Aquinas shows in this advice, proffered *c.* 1265 to princes intending to found cities, is immediately blocked by the fear that attractive surroundings might tempt the citizens to devote themselves to worldly pleasures.

In Italy it was realized early on that the citizens needed a place where they could celebrate, dance or practise archery. In Italian cities areas of grassland were accordingly set aside for them from the fourteenth century onwards: a *pratum communis* in Florence in 1290; a *prato* in Siena in 1390, dedicated 'a deletto et gaudio de li cittadini et de' forestieri'. In 1434 the town council of Nuremberg made the 'Hallerwiesen' available to the citizens, so that they could 'disport and recreate themselves'.[110] Even if it was intended that people should go for walks, few of the inhabitants were able to do so. One must also bear in mind that the real purpose of walking around in the open air was not the aesthetic experience it provided: according to the neo-platonist philosopher Marsilio Ficino, for instance, it was a means whereby the rays of the sun and the stars could reach men and women more easily and so determine their fate and mental disposition.[111]

All the celebrated gardens of the Renaissance were enclosed and therefore mostly accessible only to visiting diplomats. Yet even in this private sphere considerations of power might be involved. Only recently it has been shown that when Pier Francesco Orsini laid out the rock garden of Bomarzo in the second half of the sixteenth century it was intended to be not just a Mannerist caprice, but an ensemble inspired by political as well as personal motives.[112]

In the course of time the modern monarchies of Europe, with their growing need for ostentation and legitimation, went in for increasingly handsome parks and gardens. Thanks to these, a wider public was able to enjoy the achievements of a highly advanced horticulture. The Tuileries in Paris must have been open to the public as early as the sixteenth century. In Shakespeare's *Julius Caesar* (Act III, scene ii) Mark Antony tells the citizens of Rome that Caesar has bequeathed to them

> all his walks,
> His private arbours, and new-planted orchards
> On this side Tiber; he hath left them you,
> And to your heirs for ever, – common pleasures,
> To walk abroad and recreate yourselves.

This passage has been taken, no doubt rightly, to reflect 'current wishes and events' in England and elsewhere around 1600.[113] Charles I opened London's Hyde Park to the public in 1635.[114] From the end of the sixteenth century the Prater in Vienna was accessible to the nobility and distinguished persons, and in 1766 an *avertissement* of Joseph II stated that 'everyone, of whatever rank, can walk in the Prater and the city domains'. At the same time the art collections in the palaces were opened to public view. All but the poor and needy were admitted to the parks. In Düsseldorf, about 1776, the Elector decreed that 'the old court garden should be made into a pleasant public walk for the benefit of the inhabitants' of the city. Although the public was never admitted to the grounds of Sanssouci at Potsdam, it had access to the Zoological Garden in Berlin from 1740. Versailles, which has always been considered the most provocative show of regal splendour, is a typical example of a park designed to impress the public. When the court and government moved there in 1692, Versailles took over some of the functions of the capital, and these entailed a rigorous display of the Sun King's greatness

(illus. 65).[115] The grounds were intended for a large and respectful public. A guidebook of 1718 states that 'the park or garden of Versailles is open day and night, and all persons of whatever rank, rich and poor, young and old, of high and low estate, may enter and divert themselves'.[116] English gardens, on the other hand, though no less politically inspired, remained exclusive. In 1789, however, work on the Englischer Garten in Munich, which offered 'the first democratic greenery on the continent', was put in hand by the Elector Carl Theodor, who was then keeping his eye on the progress of the French Revolution, 'in order to promote the familiar and convivial mixing between all classes who meet here in the bosom of fair nature'.[117]

It was therefore not necessarily a new bourgeois conception of nature, imported from England, that led the Danish landscape theorist C. C. L. Hirschfeld, about 1780, to propagate the idea of a 'people's garden, where all classes could meet, see one another, perambulate and converse'. An increasingly articulate public also took advantage of such contacts in order to extend its basis to the marginal groups in society. However, in the people's gardens there should also be open places and straight avenues to facilitate 'police surveillance, which is often indispensable in such places'.[118] Moreover, virtue and manners were to be inculcated. The Englischer Garten in Munich was started as a geometrical military garden, where the soldiers were 'to spend their off-duty hours doing gardening work instead of causing a nuisance to the state and the citizens through dangerous idleness'. It also had a veterinary school, a parade ground, a tree-nursery and exemplary institutions for the breeding of cattle and sheep, so that the citizens could see 'everywhere instructive scenes of diligence and industry'.[119] To Hirschfeld the garden seemed 'to be the place where one can easily strew useful lessons in the public's path as it goes about its pleasures, and capture its attention by means of important memorials. Buildings with interesting paintings relating to the nation's history, statues of its former benefactors, monuments to important incidents and events, with instructive inscriptions, can be tastefully and advantageously disposed here at suitable points' (illus. 66).[120]

In its educative intentions, then, the bourgeois popular garden in no way lagged behind Versailles: with a particular public in mind, it 'strewed' programmatic instruction on

behaviour in all directions. Among the visitors were republicans such as August Hennings, from Hamburg, and the like-minded Joseph Rückert, who found the edification irksome. In 1797 Hennings mocked gardens that tried to impose particular sentiments and improving ideas, gardens 'where one has to stoop at every rose-tree to read a Horatian inscription'. In 1799 Rückert wished to see no more statues of princes in the parks, for 'nature is republican; with proud disdain she shakes off crowns, princes' hats, courtly splendour and vain pomp, and our hearts are formed in her mould'.[121]

Seldom has an artistic form been as politically charged as the formal garden, which flourished mainly in France, but also in the republican United Provinces. The avenues of the French gardens radiated far into the surrounding country, as if to subject town and country to the palace and draw them within the prince's grasp (illus. 65). The walks, as straight as if they had been drawn with a rule, the pruned trees and trimmed hedges, the stone-rimmed ponds and mechanical fountains – everything seemed to replicate an artificial and servile courtly existence, where one admired (to follow the Queen in Schiller's *Don Carlos*)

The anxious ceremonial of the trees
That yawn around me, stiff and all unbending,
In listless pomp, as decorous as his court.[122]

The attacks came from advocates of the English landscape garden, to whom nature was a 'symbol of freedom', because she 'arranges all objects in the landscape freely and without constraint'.[123] In the landscape garden the trees, shrubs and paths were disposed in such a way that, although their role was to create order, they appeared to perform it in freedom; there should be no straight walks leading to fixed destinations, but random possibilities that one was free to choose from. In the formal garden the growth of the trees and the routing of the paths and waterways were determined by verifiable guidelines and formal patterns; in the landscape garden the paths should follow the lie of the land, the trees should grow naturally, and the streams and lakes should obey their own laws, so that the visitor, observing how freely they developed, could discover a pattern for his own development (illus. 67).

The arguments in favour of the landscape garden carried most conviction when set against the formal canon of the

French regular garden. If this canon proclaimed princely pretension as overtly as it had done at the Wilhelmshöhe in Kassel since 1696, the criticism became irrefutable (illus. 68). Here a bronze Hercules, ten metres taller than the Farnese Hercules, stands on an uninhabitable hilltop castle, demonstrating the ruler's dominion over the forces of nature. From this Olympian height, torrents of water rush down the hillside, to be tamed in the subterranean grotto of Hades. A wild political will, one might say, has made the actions of Prince Karl of Hesse-Kassel as irresistible as the mythical forces of nature. As early as 1706 voices were raised against the cost of the project, which 'would have been better given to the poor'.[124] From c. 1750 the park surrounding the artificial hill was gradually transformed into a landscape garden, which Klopstock celebrated in verse, but this did not redeem it in the eyes of Friedrich von Rebmann, a pupil of Schiller and a radical supporter of the Revolution, who visited it in 1795. In his account of the park he wrote that while he was awake – in front of the cascades, for instance – he was able to suppress the thought 'that the tears of the subjects could also produce a substantial waterfall'. But then, having fallen asleep on a bench, he dreamt that the scenery was transformed into a horrifying political landscape:

> What shocked me was not the pyramid, but the sight of a huge pile of skulls and bones; what lay before me was not the park – it was the battlefield of Saratoga.[125]
>
> Thousands of Hessians rose from the riven earth. One trailed his intestines behind him, another had a shattered arm hanging from his torso, a third, his head bleeding, roared for vengeance. The cascades leapt, but they were now cascades of blood. Into the stormclouds rose thick vapours from the streams of blood, which became more and more swollen and at last swept away the splendid wings of the castle, together with the pleasure-houses.
>
> Anxiously I fled back to the grotto. The lightning still hissed, the thunder still rolled, the rivers of blood still roared. Mirrored on the marble walls was the horrible turmoil in the valley.[126]

It is not clear whether the geometric structure of the Baroque garden was an expression of the will to rule, as the champions of the landscape garden averred;[127] perhaps domesticated

nature was nature in the form that the age found most desirable. The first generation in England to encourage the development of the landscape garden was led by a disaffected political grouping then out of office. Recent research has revealed some of the political motivations that lay behind the symbolism of the landscape garden, which were strongly coloured by freemasonry.[128] The gardens were invariably private, but from this demonstrative withdrawal arose offensive political forces that introduced drastic changes in the formal gardens, later copied abroad (illus. 69 and 70). 'The first English gardens became emblematic propaganda parks for a constitutional commonwealth: the mock-classical triumphal ruins and busts of notable Whigs, the little agit-prop plaster temples of liberty – a moral stage-set.' From the beginning, two elements seem to have been involved: a decidedly politicized appreciation of nature and the experience of 'naturalized' art. Since perception of the landscape had been schooled by painting, motifs found in landscape painting, from Poussin to Ruisdael, were taken over and imitated in gardens.[129] The English saw the gardens as 'pictures to walk into' and landscape gardening as a 'sister of landscape painting'.[130] Horace Walpole said of the landscape gardener William Kent: 'The pencil of his imagination bestowed all the arts of landscape on the scenes he handled. The great principles on which he worked were perspective, and light and shade.' The nature that was sought in the landscape garden was hardly the untouched, random nature that existed outside it, but 'rather nature as reflected in poetry, painting and history'.[131] Hirschfeld maintained that landscape gardening excelled landscape painting 'as nature excels its copy. None of the imitative arts is more interwoven with nature – more natural, as it were – than the gardener's art. In it everything becomes a true representation.' Herein, no doubt, lay a political threat: the arcadian images of nature that hung as paintings in the gloomy galleries of the great were now to be reproduced and made accessible as reality. The painted fictions were to become real life. Hirschfeld went so far as to assert that the landscape gardener strove, 'by a more careful mixture of colours, to excel nature, who was careless in the design of her great, free works, and to produce, through a new combination, a new whole that constitutes, as it were, a painting of greater perfection'.[132] Hence in 1752, when the author and garden

designer Joseph Spence defined the garden as a picture gallery under the open sky, one could clearly imagine that the hallowed halls of art might become a roadside reality.[133] It was this combination of the artistically beautiful with the real, this profanation of artistic beauty, that made the landscape garden a matter of political bias. Of course, the critical impulse was hedged in by many safeguards, by iconographic programmes of virtue, by commemorative stones, by temples of friendship and sensibility,[134] in short, by moderating influences that laid various constraints on the notion that the fictions and fantasies of art could be given absolute reality. Impressed by the events in France, the advocates of the English garden soon began to temper their advocacy. In 1795 Schiller claimed that the programme of the landscape garden had failed 'because it had exceeded its bounds and brought the gardener's art into painting', and because it had replaced 'the harshest slavery by unbridled licence' and now wished 'to be ruled by imagination alone'.[135] Before long the landscape garden was so obviously discredited that in 1801 Herder's pupil Garlieb Merkel, a staunch republican, had to employ the more powerful image of the forest when he wished to invoke nature in support of his political arguments:

> Travelling through a monarchy, even the best, is like walking through a Dutch garden, along straight, level paths, between plain walls, fountains and box hedges, where each arbour promises that another just like it will be found on the other side, and where art gives every single tree a shape that is most appropriate to a particular purpose at the spot where it stands, but bears scant resemblance to its original shape. . . . A republic, on the other hand, is like a carefully tended forest. Every trunk strives upwards with all its might, stretching its great arms, so long and so thick with foliage, as far upwards and downwards as its inner force allows. Whatever is in its proper place flourishes; whatever is sick and defective dies. The only task of art is to keep the soil pure. . . . The various shapes and groupings of the trees, the powerful force of nature that is to be seen everywhere, even the unlevel ground and the sources that flow through it at will and often force the walker to jump or to divert his steps, afford him such delight as he would seek in vain in the pleasure gardens.[136]

The landscape garden having been criticized for its meretricious imitation of nature, the almost virgin forest is now taken to represent freedom: it is better to seek out raw, untouched nature herself 'than to go to laborious and pitiful lengths to summon her'. Ludwig Tieck referred disparagingly to English landscape gardeners as 'manufacturers of fair nature', because they began 'to paint in a variety of ways with trees, shrubs and rocks'. Mixed with the rationalist argument was a fear of what might result if artistic fictions were to become reality. Tieck was accordingly glad to revert to the French formal garden, in which the interior of the house was simply continued out of doors and the visitor found nothing to 'disturb or confuse him'. It was 'magically surrounded by living nature, in keeping with the same rules according to which man is eternally enclosed by reason and understanding and by the invisible inner mathematics of his being'. In 1831, with cynical irony, Tieck dismissed the educative pretensions of the landscape garden:

> It is possible (and indeed a pleasing notion) that mankind will in future rise so high that one need only push some criminal or godless doubter gently through the garden gate and then, after two or three hours, let him out at the other side as a convinced believer and a man of virtue.

The extent to which the pathos of the Enlightenment had been dissipated is clear when we find Tieck, in 1834, speaking freely of the 'monotonous, melancholy English gardens, which can sooner be called a reversion to barbarism than boast of being a genuine and superior form of horticulture, indeed the only true one'.[137] At this point the garden dropped out of the history of the political landscape; it became a place of recreation that no longer appealed to the visitor's need for freedom, his virtue or his morality, but merely restored his capacity for work.

Meanwhile, from the beginning of the eighteenth century, the growing popularity of the landscape garden was paralleled in many French and German towns by another development in the political landscape that perhaps did more to promote a sense of freedom than the slow greening of individual free spaces: town fortifications were being dismantled and the ramparts grassed over. Goethe remarked appositely, 'Even large towns are levelling their ramparts; even the

moats of princely castles are being filled in; the towns are now nothing but large villages, and when one sees this on one's travels, one would think that universal peace had been established and the Golden Age was just outside the gate.'[138] Goethe's comment captures the new political experience that defortification could bring to the citizens: 'universal peace' implied not only that new military techniques had made the towns indefensible, but that a new reciprocity was possible between town and country. If the 'discrepancy between power and morality, between the real and the ideal, was once associated with the contrast between town and country',[139] then its removal in the wake of defortification might indeed seem like the return of the Golden Age. Yet the new openness could also arouse anxieties, such as are expressed in a petition presented in 1791 by the citizens of Munich; this pointed out that while the city's fortresses could no longer withstand a major assault, they were still 'proof against a first attack by small enemy forces', and that it was therefore unwise to demolish them.[140] The ramparts were not always turned into promenades or gardens, as they were in Paris, Münster, Bremen or Hamburg, but often made way for roads or new buildings. And when defence was replaced by recreation, this was often linked with education and civic enlightenment. Monuments were set up not only to princes, but to local worthies, past and present; the old town was thus enclosed by a 'garden of virtue'.[141] Similar motives may have lain behind the frequent siting of cultural institutions such as museums and academies in the areas that were formerly taken up by the town's defences. Since the idea of education was no longer linked with the acquisition of a capacity for freedom, but with the enjoyment of leisure, these foundations were part and parcel of the same structural change that turned parks and gardens into objects of a kind of 'green politics' oriented towards health and recreation.

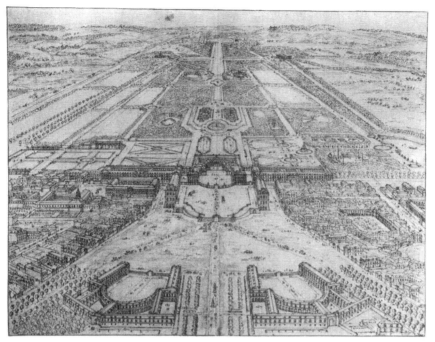

65 Israël Silvestre, engraving of a bird's-eye view of the grounds at Versailles, c. 1690.

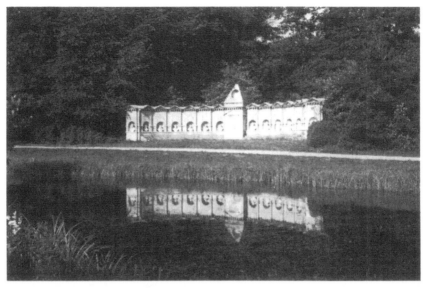

66 William Kent, Temple of British Worthies at Stowe, Bucks, 1735.

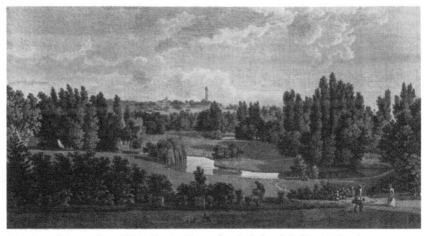

67 View of the park at Méréville, in Alexandre de Laborde's *Description des nouveaux jardins de la France . . .*, Paris, 1808–14.

68 Hercules above the cascade at the Wilhelmshöhe, Kassel, after 1696.

69 François Cuvilliés the Younger, plan of the buildings and gardens at Schloss Nymphenburg, 1772.

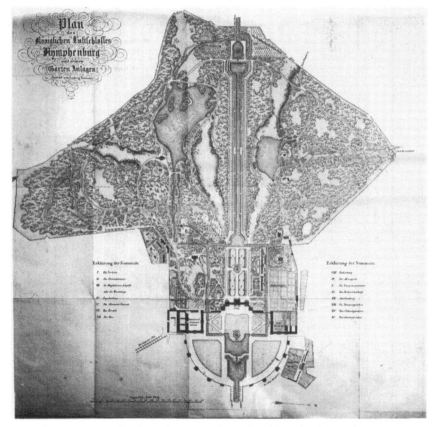

70 Ludwig Emmert, plan for redesigning the park at Nymphenburg, 1837.

71 J. B. Fischer von Erlach, engraving of Chinese-style artificial mountains, 1721.

72 Engravings of rockwork, from George Le Rouge, *Jardins anglo-chinois*, Paris, 1767–87.

5 Natural Forces and Natural Forms

A country and a nation can be epitomized and represented by an individual. This is a basic motif born of political experience.

When painters or sculptors have portrayed rivers and mountains – or the earth itself – in the form of human beings, these have mostly been passive figures lying on their backs.

Once a landscape formation is perceived and represented in anthropomorphic terms – as a resting giant, for example – an imaginative scheme has been created that can be realized in a variety of ways. In Joos de Momper's 'head-landscape' (illus. 73)[142] the face of a recumbent male monster is presented as an accessible landscape, where the shepherds outside the enclosed area can tend their sheep, where milkmaids can carry their pails home unmolested and wanderers can gaze into the distance. This giant's face seems to hint at subterranean processes of parturition that have been pushed upwards and halted on the surface.[143] In G. B. Braccelli's *Bizarreries* of 1624, the body of a city is seen as a resting giant, but fortresses are placed at every point where movement would have been possible (illus. 74); in this position the armed giant is at the same time subdued and no longer a threat. In J.-B. Debret's travel journal of 1834 another giant, likewise not to be taken altogether seriously, represents Brazil (illus. 75);[144] here the horizontal figure is reminiscent of a dead Christ and so reinforces the impression of paralysed power. However, if the state assumes an upright posture and becomes an active figure, it unleashes traumas associated with all-consuming power. The title-page of Hobbes's *Leviathan* shows the state, which contains all its subjects within it, attempting to act as an autonomous entity (illus. 76). This state can be armed in such a way as to try to force its subjects into an ideological, perhaps national solidarity. Goya's giants make this clear, and Daumier demonstrates it in *Le Réveil de l'Italie*, in which a Gulliver with a Garibaldi beard rises to his feet and puts the 'subjects' to flight (illus. 78):[145] the foreigners who have established themselves in Italy are to be taught a sharp lesson. An Austrian propaganda postcard of 1928, with the legend

'One People – One Reich', depicts the all-powerful mother Germania, in whose presence only adulation or death is admissible (illus. 77). The motif seems to derive from Hobbes's title-page. Here, however, the main figure is no longer composed of the individual subjects, whose disappearance would cause it to collapse; it has become a dominant figure, which the subjects approach in adoration, unless they choose annihilation.

The artistic idea of transforming a landscape by creating a huge figure originated as a kind of temptation. Dinocrates presented Alexander the Great with designs that showed Alexander's statue carved out from Mount Athos, 'holding in his left hand a large city and in his right a basin into which all the waters of the mountain emptied themselves in order to be cast into the sea'. Vitruvius tells the story in the preface to his treatise on architecture, written for Augustus; Alexander is said to have rejected the plan because the city in his hand was cut off from all sources of nutriment. According to Lucian, he declined the offer out of modesty, being aware of his limitations.[146]

The concept of natural giantism was born in the ancient world and for a long time took the form of the colossus. Yet it is only in modern times that artists have looked for a practical explanation of Dinocrates' intention, which at first – in the fifteenth century – was regarded with a mixture of curiosity and revulsion. Vasari relates that when Michelangelo visited the marble quarries of Carrara in search of material for the tomb of Pope Julius II at St Peter's, he felt challenged by the massive blocks 'to carve giant statues there in order to leave a memorial to himself, as the ancients had formerly done'. The memorial to the prince becomes a memorial to the artist too. Orsini was clearly intent on combining both in the fantastic rock garden of Bomarzo.[147] In a drawing intended to be engraved, Pietro da Cortona portrayed Pope Alexander VII inspecting a realization of Dinocrates' project (illus. 79).[148] The artist shows the Pope his plans for restoring the ancient 'landscape of power'. In the age of absolutism, which claimed to excel the ancients, Alexander's arguments no longer counted (illus. 80).

Interest in the anecdote focused on the motives of those involved, but the significance of the figure envisaged by Dinocrates was clearly not yet considered. Alexander saw that

the whole project was chimerical, for the city would be cut off from all resources, and the water that had been so laboriously collected would flow uselessly into the sea. Interpreted symbolically, however, the figure described to us acquires a meaning. In one hand Alexander holds the city, the quintessence of a civilized, ordered polity, while in the other he collects the sources of natural power. Every living thing is dependent on his favour. In 1640 the Spanish diplomat and emblematist Saavedra Fajardo, expatiating on the omnipotence of the prince, invoked the kingly image of the mountain:

> Scripture likens princes to mountains, and others to hills and valleys (Ezekiel 6.3). There are many points of likeness. The mountains are the princes of this earth, being closest to the sky and superior to the other works of nature. Moreover, they resemble princes by virtue of the generosity with which their great bowels slake the thirst of the fields and valleys with inexhaustible springs and so clothe them with leaves and flowers; this is the virtue most proper to a prince. Through it, more than through any other, the prince resembles God, who provides abundantly for all.

Princely liberality is thus aptly symbolized by the mountain, for 'the mountain also makes good use of the snow at its peak, produced by the vapours that rise from the fields and valleys; it conserves these for summer and gradually distributes them, by freeing the streams, to those who first contributed them'. Further,

> Princes resemble mountains not so much because they are closest to the favour of heaven, but because they suffer all the inclemencies of the weather and endure the disfavour of the elements, being the places where hoarfrost and snow gather, which are later transformed into streams that flow down to quench the thirst of the fields in summer and fertilize the valleys, and also because their upright bodies provide the latter with shade and shield them from the rays of the sun. For this reason Scripture calls the princes giants, ... and also because they must be especially strong in order to bear the burden of rule.[149]

Here the mountain, a tall natural feature, is used to symbolize the prince. A portrait bust hewn in the mountain supplies a natural vindication for his personal claim to rule and for the

symbiosis of land and ruler. The prince's portrait, shaped out of the land, can be interpreted by his subjects as a demand that they should identify themselves with him, or as an offer, on his part, to merge with them. At any rate Fajardo tries to extract some advantage for the subjects from the comparison between the prince and the mountain, for in him the water veins come together in such a way as to benefit all his subjects equally; the prince is thus the distributor of nature's wealth. A similar view was taken by Fischer von Erlach, who thought Dinocrates a *mauvais économe* and introduced certain obvious corrections in his reworking of the idea (illus. 81). Both the basin and the city slip from the ruler's hands. The city now extends over the mountain slope, while the basin is placed at a hydraulically useful height, so that the water can benefit the city before finally cascading down the cliffs into the sea.[150] The city is thus linked to a source of nutriment, as Alexander required, while the older comparison between the generous prince and the river flowing into the sea is acknowledged.[151] Such a profusion of blessings echoes the wishful thinking in Hölderlin's lines: 'The spring babbles, poured out by pure hands, as crystalline ice is touched by warm rays, and the snowy peak, transformed by gentle, stimulating light, drenches the earth with purest water . . .'.[152]

Fajardo's positive approach to a form of natural giantism that seems to us the acme of despotic presumption also explains why rock sculptures can be so popular. In 1770, at the court of Ansbach, a colossal figure of Frederick the Great was planned; it was to be fashioned by Jakob Atzel, the Margrave's architect; the monarch was to be seated on a hill, gazing pensively into the clouds (illus. 82). This was a kind of courtly compliment.[153] The twentieth century has produced monumental sculptures, realized through gigantic projects and comparable with those of ancient Egypt, though they have clearly arisen spontaneously. About 1925 an American picture agency distributed a photograph, published in a number of magazines, that showed a Russian artist in the Crimea standing in front of a head of Lenin carved from a rockface (illus. 87). It must have been known to the sculptor Gutzon Borglum when he decided to honour the founding fathers of American democracy in the name of the people (illus. 84).[154] And when work began on 10 August 1927 President Calvin Coolidge declared the project a national monument. This 'shrine of

democracy' consists of monumental busts of Washington, Jefferson, Lincoln and Theodore Roosevelt, cut in the steep rockface of Mount Rushmore at a height of 70 metres. It was completed in 1941. The popularity of this politicized landscape in South Dakota is attested by the fact that it has been copied in Legoland in Denmark. It may one day be surpassed by the monument to the Sioux chief Crazy Horse, also in South Dakota (illus. 83). If it is ever completed, this 'giant equestrian statue carved out of a mountain ridge will be 172 metres high, taller than the Cheops Pyramid at Giza. In the head of the rider, due to measure 27 metres, there would be room for a handsome villa, and the horse's nostrils could accommodate a bungalow.'[155] The impulse behind such endeavours is not essentially different from that which has favoured less honourable figures: 'During their last campaign in Abyssinia, Italian soldiers carved a figure of the Duce from a great block in the plain of Adua in order to perpetuate the memory of the man who had expunged their former disgrace and restored their martial honour'.[156]

Some recent monuments have resorted to natural giantism in order bolster unpopular regimes: while the Marcos monument (illus. 88) at Baguio in the Philippines alludes directly to the figure of Ramesses (illus. 85), the Lenin monument in Berlin grandly incorporates the rock from which the figure was carved (illus. 89).

It is curious that political fantasies repeatedly attach themselves to the landscape, take hold if it, reshape it and adapt it to their needs. The desire to demonstrate one's rule over a country and its inhabitants may seem natural, but to an enlightened view it is not so obvious why this should be done by means of giant figures that far exceed all natural dimensions.

There is also a democratic variant of natural giantism. On the island of Rhodes a figure was conceived that would tower over the plain; its purpose, however, was not to subjugate, but to welcome. It was intended as a symbol of a democratic community that had successfully defended itself against a blockade mounted by King Demetrios in 305–4 BC. Using the proceeds of the abandoned siege machines, the Rhodians commissioned the sculptor Chares of Lindos to set up a bronze colossus, some 33 metres tall, representing the sun-god Helios. Similar statues were subsequently placed at the

entrance to the port of Ostia, near Rome, and Flavius Josephus writes of Caesarea in Palestine: 'On both sides of the entrance were three colossal statues set on plinths.[157] Condivi relates that when Michelangelo was in Carrara in 1505 he contemplated the landscape one day and was seized with a desire to shape a colossus out of a hill overlooking the sea, so that it could serve as a beacon for mariners from afar'.[158] An Italian pilgrim who visited Rhodes in 1394–5 was the first to record that the famous Colossus had once straddled the harbour entrance. Marten van Heemskerck attempted detailed reconstructions of the scene (illus. 90, 91), placing the sun-god astride the entrance as both a signal and a gateway. In the engraving Helios holds in his right hand a smoking sacrificial basin, like the beacon with which Bartholdi's Statue of Liberty on Bedloe's Island greets new arrivals at the entrance to New York harbour.[159] It was no doubt in keeping with democratic ideas that Helios should thus provide orientation and by his stance deliberately emphasize the accessibility of the harbour. Even when the motif was transferred to other gods, for instance to Mercury on a Hamburg medal of 1636 (illus. 93), the Rhodian gesture was one of greeting: the blessed harbour welcomed the fruits of land and sea.[160]

The bronze Colossus of Rhodes was unstable and collapsed during an earthquake about 50 years after it was set up in 224 BC. An Austrian medal of 1709 (illus. 92) links this event with the fall of Mons in that year:[161] the monument that had once marked a victory following a siege is now used to mock a defeated town. The *Bavaria* on Munich's Theresienwiese, on which the sculptor Ludwig Schwanthaler began work in 1837, sought to capitalize on the instability of the Colossus of Rhodes:

> What a work it was, until this Bavarian colossus was erected! Unless it is destroyed by human hand, no earthquake will cast this down. For nearly 2000 years no such work has been put in hand. . . . After the Colossus of Rhodes, the acknowledged wonder of Chares, . . . the *Bavaria* is the greatest statue ever cast.[162]

What Schwanthaler's *Bavaria* shares with the Colossus of Rhodes and the Statue of Liberty is the gesture of openness: it welcomes people and is accessible to them. By contrast, the Bismarck monument in Hamburg (illus. 97), set up near the

harbour in 1906 by Hugo Lederer at the behest of the Senate, cannot resolve upon a sign of welcome: the German people are too reliant on a demonstration of the reserved warrior strength of Roland. In 1923 the French occupation of the Ruhr was attacked by means of a German practice-target image that showed a colossus crushing human beings in its hands and crossing the Ruhr with bloody feet.[163] It is clear that an iconographic tradition had no chance of survival in the face of modern nationalistic hatred (illus. 96).

It is not only tradition and previous example that prompt the setting up of a giant figure to dominate the landscape when an irrefutable message is to be conveyed to a country and its inhabitants. Elementary forms of dominance and subordination, of sending and receiving, which are to be strengthened, intensified and perpetuated by reference to natural conditions, are also brought into play.

The landscape provides a wealth of possibilities for projecting such messages, and these are seized on when something extraordinary has to be expressed, confirmed or vindicated.

Certain natural events – earthquakes, floods and pestilences – have always been construed not only as apocalyptic signs, but as political portents. After the French Revolution the air was perhaps so full of political watchwords that the slogans of Liberty could actually be read into the lavas spewed forth by Mount Vesuvius (illus. 98). The upheaval in human affairs seemed to be accompanied by an equally violent upheaval in nature. Freaks of nature that seemed to defy natural laws were interpreted as confirming the revolutionary impulse. But permanent topographical phenomena too, which to an enlightened view might appear 'sublime', were often credited with political significance. Transferred to the political plane, 'sublimity' becomes the possibility of binding people emotionally through a show of greatness and force, making them subservient, psychically if not legally. In the 'patriotic landscape' of the period around 1800 the Alps became the witnesses and citadels of ancient liberties. On the other hand: 'In the literature and journalism of the late Enlightenment, winter, glaciers and ice were frequent symbols of the old despotic order, which would inevitably be followed, in accordance with the laws of nature, by the thaw and the warming sun of liberty.' Much earlier Thomas Aquinas had said that subjects held in fear by a tyrant were like water,

'which, having once found an outlet, flows out with all the more force if it has previously been contained by force'.[164]

A diary entry by the painter Joseph Anton Koch tells how he was seized with political euphoria on contemplating the falls at Schaffhausen in 1791:

> In the depths the raging snow-white river boils and foams, and its thunderous waves, driven relentlessly forward, divide and rise skywards. . . . The sublime spectacle deeply stirred my soul, oppressed as it was by false gods; my blood surged and my heart pounded like the wild river. It seemed as if the god of the Rhine were calling to me from the jagged rock: Stand up! Act! Bestir yourself with steadfast fortitude! Pit yourself forcefully against despotism! Rend the shameful bonds that bind you! Be unshakeable, like the rock against which I fight, in defence of the freedom of mankind![165]

Today these words are invariably quoted in connection with Koch's painting of a waterfall (in the Kunsthalle in Hamburg: illus. 100),[166] in order to explain the political motives behind this landscape. Yet a striking quotation can easily blind one to the obvious. Even if one did not have to assume that when the picture was painted – in 1796, five years after Koch's diary entry – not only politics in general, but the painter's own political views, might have changed, the picture itself shows that one can no longer speak of the waterfall's thirsting for freedom.

In 1791 Koch made a drawing of the Falls of the Rhine in which the masses of water do indeed force themselves irresistibly into the foreground; the rocks seem to quiver under their onslaught (illus. 101). Here one can appreciate how the 'image of streaming torrents became an image of freedom in the age of the French Revolution'; in this drawing the triumph of the mobile over the static may indeed be a metaphor for the 'indomitable desire for freedom in the face of rigid social forms'. Yet this can no longer be said of the waterfall picture in the Hamburg gallery, which is thought to represent a scene from the Bernese Oberland.

In the middle of a rocky tract of woodland the water of this fall has worn a deep, jagged cleft in the stone; the farther the erosion proceeds, the more the water buries itself and its excavating activity.[167] Like the wings in a stage-set, the steep

rockfaces – which admit of a slightly anthropomorphic reading – close in on the foaming cascades from left and right, as though a chapter of natural history were to be brought to an end. The water no longer forces its way out of this massive encasement. Higher up, the stream unexpectedly gushes out from two crevices in the rock, then broadens out into a steaming torrent, whose descent is checked at successive levels, where the water builds up and presses backwards rather than forwards; the light too appears to break up the water into foam and spray, rather than to concentrate it, so that little force is involved when the rocks below, in a pincer movement, block off its remaining energies. The scene ends with the babbling waters happily rejoining the normal course of the river, finally tamed – like the roaring cascades of Hercules at Kassel. Koch adds explicit hints on the nature of this process, as though a commentary were needed. Towards the upper right and from the lower-left corner, broken branches protrude like dragons, as if mocking the spectacle. Human figures are inserted at crucial points. Above, at the source of the waterfall, a man kneels by the crevice from which the water frees itself, while another seems about to sink to his knees in pious awe. Yet at the foot of the waterfall a lightly clad youth approaches from the right and, on reaching the promontory, sees that he can go no farther: the waterfall itself is no longer accessible to him. Leaning forward and supporting himself on a long staff, which he holds in both hands, he stares broodingly at the ground before him or at the gently murmuring water.

A sepia drawing by Koch of about three years earlier is less pessimistic (illus. 99).[168] The rocks are not yet so overgrown or set so close together; the masses of water are not yet so shallow, as if homogenized into a snow figure. The tree-trunk at the lower left seems to be sinking with a gurgle rather than creeping insolently forward. The youth is still driven by a powerful impulse: his hair does not fall over his brow, but is blown back over his neck. The painting transforms the metaphor of the waterfall intoxicated with freedom into an image of liberty blocked, confined, faltering, exhausted.

If it is permissible to compare Goya's late etching *Landscape with a Waterfall* (illus. 102) with Claude-Louis Châtelet's gouache of the waterfall on the Fiume Grande (illus. 103) and to interpret them in the same terms, it may be said that here

natural giantism really comes into its own. In the work of Châtelet, a revolutionary who was to be guillotined in 1794, the waterfall is clearly a superior force; the rocks are fragmented and abjectly surrender to the torrent and the abyss, which will swallow them up; small human figures celebrate the promised liberation that will overcome all resistance and cannot be delayed. The opposite is true of Goya's work of c. 1810: the waterfall here is tame and expansive, the masses of water being unable to gather themselves into a single force, and supplies only a background murmur to the spectacle of the huge rock in the foreground, which seems 'almost like a giant retransformed into a natural shape'.[169] If the waterfall represents freedom and the rock represents bondage, then Goya seems to have come to a dispiriting conclusion about the revolutionary movements of his age.

We must now consider the countless political landscapes that figured in the festivals of the French Revolution. It is one of the contradictions of the Revolution that its claim to establish 'a society on the model of nature'[170] called forth the most bizarre constructions. Among these are the 'holy mounts' implanted in cathedrals. In 1794 a kind of grotto path was laid along the central aisle of Bordeaux cathedral and drawn together at the west end in the form of a snail's shell (illus. 105). In Strasbourg cathedral, renamed a temple of Reason, a hill was constructed, in the bowels of which personifications of the vices and abuses of the *ancien régime* writhed and made their last jests before they too were struck down by Liberty, who appeared on high beside the statue of Nature. On the Champ de Mars in Paris, Jacques-Louis David staged the festival of the Supreme Being and placed the 'holy mount' at its centre. As a symbol of the extremist *Montagnards*, the mount does not represent nature, but a particular party's claim to power (illus. 106).[171] The flysheet showing the culmination of the festival, at which Robespierre delivered from the steps his speech on the Supreme Being, partly conceals the competing column surmounted by the figure of the popular Hercules, with whom only the people's representatives have dealings, standing at the summit of the hill, under the Tree of Liberty. The mount as a whole appears strangely rugged, as if its irregular shape had been copied from works by Mantegna; what we see is a kind of nature monument that could be construed as an enormous head, but the caverns,

paths and platforms also serve to direct the movement of the crowd: the men march on the right, the women on the left; the young people march round the hill, and a special *commissaire* sees to it that there is no confusion.[172] Only optically does the landscape admit of irregularity and contingency. It belongs to the type of fantastic landscape that once rose towards gold skies in the backgrounds of altarpieces, in the early days of landscape painting. Yet the overall physiognomy of the rock still has some of the impressive force attributed to faces in mountains.

73 Joos de Momper, *Head-landscape*, before 1635.

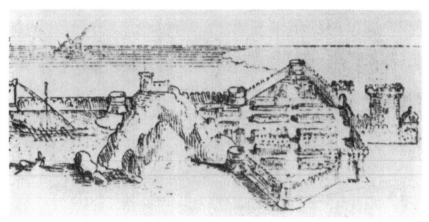

74 G. B. Braccelli, A city as a sleeping giant, from his *Bizarreries* of 1624.

75 Jean-Baptiste Debret, *The Sleeping Giant*, a travel illustration of the Brazilian coast.

76 Title-page of Hobbes's *Leviathan* (London, 1651).

77 *One People – One Reich*, an Austrian propaganda postcard of 1928.

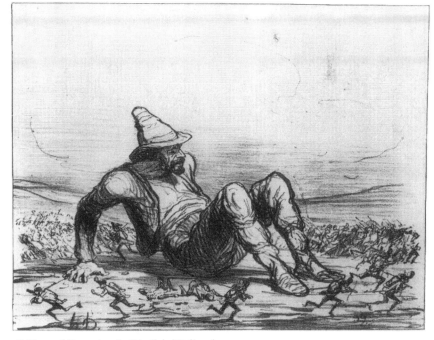

78 Honoré Daumier, *Le Réveil de l'Italie*, 1859.

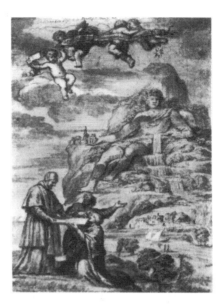

79 Pietro da Cortona, drawing of the artist showing Pope Alexander VII Dinocrates' project for the Mount Athos monument to Alexander the Great.

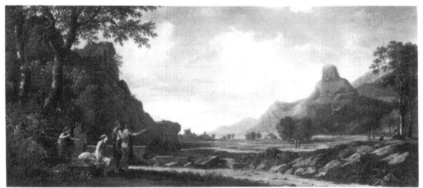

80 Pierre-Henri de Valenciennes, *Mount Athos, carved as a monument for Alexander the Great*, 1796.

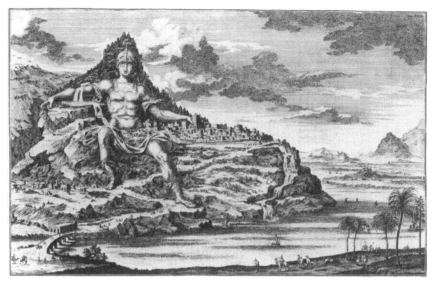

81 After J. B. Fischer von Erlach, The Mount Athos monument of Dinocrates to Alexander the Great, 1721.

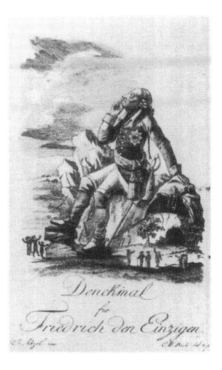

82 Josef Atzel's planned monument for Frederick the Great, 1770.

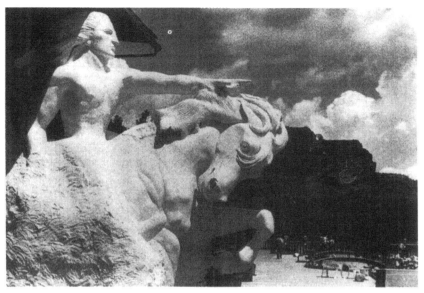

83 Korczak Ziolkowski and family, model for the Crazy Horse Mountain, a monument in progress to the Sioux chief (visible in the background), South Dakota.

84 Gutzon Borglum, mountainside portraits of George Washington, Thomas Jefferson, Theodore Roosevelt and Abraham Lincoln, the founding fathers of American democracy, 1927–41, Mount Rushmore, South Dakota.

85 Temple figures of Ramesses II in the sandstone cliff at Abu Simbel, Egypt
(c. 1290–1224 BC).

86 A cartoon by Low in the *Evening
Standard* of the 'Hoover face-building
enterprise', 1929.

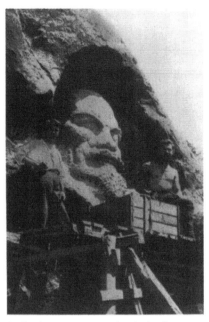

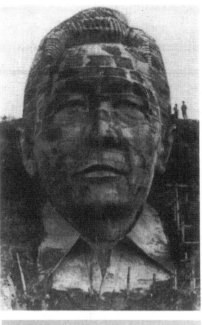

87 Rock-monument to Lenin in the Crimea, c. 1925, with the sculptor and an assistant.

88 Monument to President Marcos near Baguio in the Philippines.

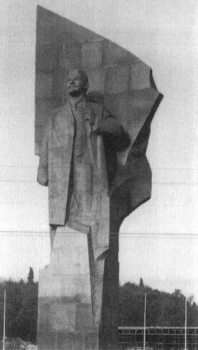

89 Nikolai Tomski's Lenin monument of c. 1966–9 (until 1991 it stood in the former Leninplatz in Friedrichshain, Berlin).

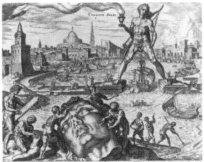

90 Philip Galle, after Maarten van Heemskerck, A reconstruction of the Colossus of Rhodes, 1572.

91 Maarten van Heemskerck, Detail from *Panoramic Landscape with the Abduction of Helen*, showing the harbour at Rhodes, 1535.

92 Martin Brunner, the collapse of the Colossus of Rhodes, on a silver medal of 1709.

93 Sebastian Dadler, Mercury as a harbour sculpture, on a silver medal of 1636.

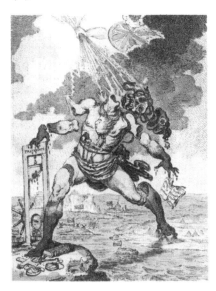

94 James Gillray, *Destruction of the French Colossus*, 1798.

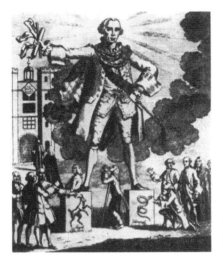

95 *The Colossus*, the State as bountiful yet corrupt, standing on legs of Lust and Fraud, 1767.

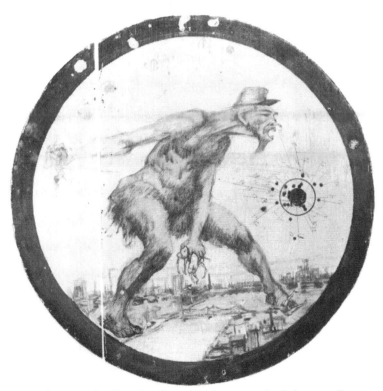

96 A colossus with a French military *képi* devastates the Ruhr, on a German wooden practice target, probably after 1923.

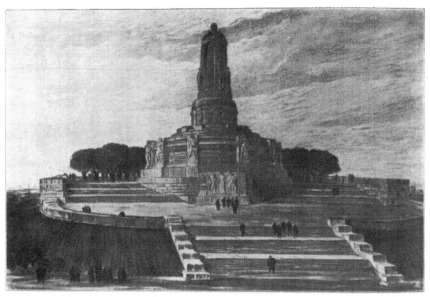

97 Emil Schaudt and Hugo Lederer, a design for the Bismarck monument in Hamburg, 1901.

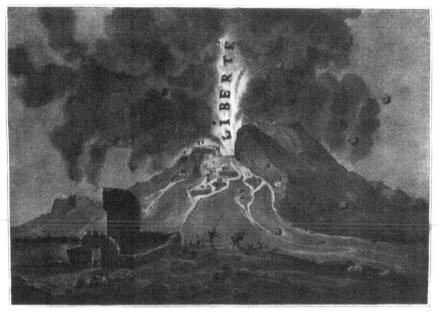

98 A. Desperet, *The Third Eruption of the Volcano of 1789*, from the journal *La Caricature*, 1833.

99 Joseph Anton Koch, Sketch of a
waterfall, 1793/4.

100 Joseph Anton Koch, *Waterfall*, 1796.

101 Joseph Anton Koch, *Falls of the Rhine*, 1791.

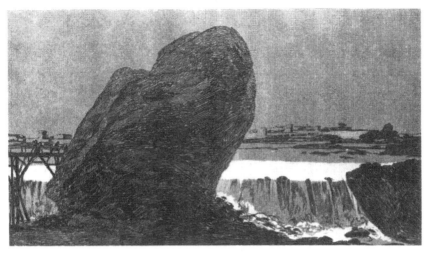

102 Francisco de Goya, *Landscape with a Waterfall*, c. 1810.

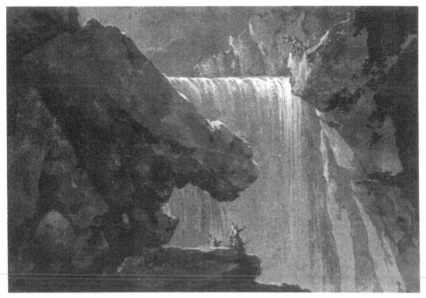

103 Claude-Louis Châtelet, *The Waterfall on the Fiume Grande*, before 1794.

104 The site of the Spanish Steps in Rome transformed into a landscape in honour of a visit by the Dauphin, 1662.

105 Alexandre-Théodore Brongniart's design for a holy mount in Bordeaux Cathedral, 1794.

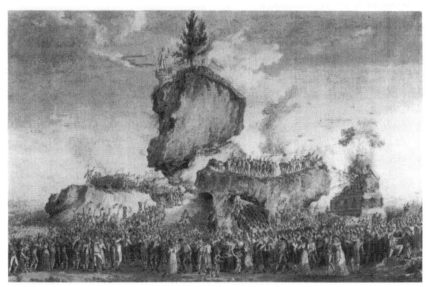

106 The holy mount for the Festival of the Supreme Being, Paris, 1794, staged by Jacques-Louis David.

6 Political Nature Imagery

It is reckoned a signal achievement in the European history of ideas that nature can be seen as nature. This ability supposedly evolved as we freed ourselves from a nature dominated by magic and superstition. Nature was no longer overlaid and obscured by alien connotations, by the imposition of religious or moral meanings. The new scientific view of nature was then joined by an aesthetic view, which, it is argued, in the Romantic era amounted to a redefinition of man's relation to the world.

Even if there is no reason to reject this scheme of evolution, we may nevertheless presume that it followed a rather more complex course. The question is whether the one would have been possible without the other. Before I assign a meaning to a natural object, I must first have been struck by its special qualities. If I call Jesus a sun, I must first have learnt to appreciate that the sun's warmth is beneficial to me and that its light enables me to see my way and recognize objects. If a poet or an artist creates a metaphor based on this experience, the result may be that the intended meaning brings out more forcefully the natural properties of the object in question: in other words, the meaning assigned to it may influence and intensify the empirical experience.

The fact that landscape motifs can repeatedly be invested with religious or moral significance is obvious to anyone who has heard talk of the Way of Truth or the Path of Virtue or of 'light and shadow' in human life. Christian art knows the green and the dry tree in the iconography of the Passion, the landscapes of heaven and hell (the bright hills and dark vales), the topography of paradise. The Sermon on the Mount clearly contains suggestions for a moral landscape, which above all captured the interest of Netherlandish artists in the sixteenth century, when religion took on the important task of providing spiritual orientation:

> Enter ye in at the strait gate: for wide is the gate, and broad is the way, that leadeth to destruction, and many there be which go in thereat.

Because strait is the gate, and narrow is the way, which leadeth unto life, and few there be that find it. (Matthew 7. 13–14)

Landscape paintings thus had to abandon panoramic uniformity in favour of polarization and fragmentation.[173] About 1580 an anonymous artist depicted the narrow way and the broad way: the former, on the left, winds up a tall hill with a round temple at its top (illus. 108); the latter, on the right, leads straight into the city through a broad arch, on which a sculpture of Bacchus promises the greatest delights. In this landscape of contrasts, city and castle are juxtaposed as in Lochner's *Last Judgment*, though here, for some reason, the castle is the desirable destination, while the city appears as a cesspit of vice.[174] In this *paysage moralisé*, the artist is not troubled by the fragmentation of the landscape or by the fact that the two paths start at different levels. Govert Jansz. places a wide and somewhat dilapidated gate in the middle ground, next to a poor, narrow one, but includes a foreground area from which both can be advertised (illus. 107). Most of the people hasten to the right to join the courtesans, dancers and gluttons in the fields of pleasure, where in the far background a hill spews out flames; the few who press through the strait gate on the left have an arduous climb ahead of them, but at the summit a handsome domed building awaits them.[175]

In the education of princes, the bifurcation of the broad and the narrow way, the *bivium*, was adopted as a pedagogic device. In a Milanese miniature of *c.* 1496 (illus. 109), Massimiliano Sforza has to choose only between two women who represent respectively Virtue and Vice, not yet between a good and an evil landscape; indeed, he is shown only the one way, which leads through rocky country to a splendid hilltop castle.[176] However, an engraving of 1595 (illus. 110) shows Maximilian, the heriditary prince-regent of Bavaria, as a naked Hercules, obliged to choose between light and dark, between stony paths on the one hand, leading to the peak of fame, and on the other, roses and a vine bower, which are followed by thunder and lightning.[177]

The politicization of landscape moods obviously began when painting had discovered landscape as landscape *per se*. As the technique of the 'atmospheric landscape' was developed in Venice, it was here that the landscape was first

endowed with qualities that made it possible not only to construe, but to experience, the meaning of a picture. About 1515, in an allegory of a Venetian victory, Giovanni Cariani, who was trained in the circle of Giorgione, was not content simply to place the three significant figures – Fortuna, Musica and Natura – under a tree in the foreground and have the harmony of peace celebrated with music (illus. 111), but allowed the background landscape to participate in the decision between war and peace. On the right we see a burning castle under siege, on the left the Venetian lagoon, with a view of the city's skyline; on the right a great smoke-cloud rises into the sky, threatening to turn a dark, grey day into a black one unless a bright front of clouds spreads across the scene of the fighting from the left of the picture, where the blue lagoon is dotted with ships. It followed from the concept of the Venetian 'atmospheric landscape' that the harmony of the whole was disturbed and dissonant when the landscape was split into two emotional spheres. The theme of Cariani's picture is the reversal of such a split; to achieve this he uses the wind to drive the peaceful cloud formations across the scene. Even the figures in the foreground can feel the wind: hair, branches, garments and notes of music are stirred by the breeze. A landscape can truly represent peace – this is what the artist is saying – only if the entire mood is sunny, as in the works of Bellini or Giorgione.[178]

Involving the landscape in human affairs and feelings, and representing these by means of internal contrasts, became a familiar dialectic technique in the sixteenth century.[179] The landscape could also be treated in such a way as to impart a political message to a wider public. The Venetian ambassador to London reported an instance of this in 1559, the year of Elizabeth I's accession. On the processional route was a tableau that showed on one side a hill, with a dying tree and a seated figure lamenting the *ruinosa respublica* he had witnessed during the reign of Mary Tudor; on the other side, another figure stood on a green hill, looking forward to a *respublica bene instituta* under the new monarch. Between the hills lay a dark cavern, from which Time at last allowed Truth to emerge into the light. This allegorical landscape was so impressive that 70 years later the Lord Mayor of London was able to use it as a statement of political intent on assuming office.[180] In the war-torn seventeenth century the contrasts could become more

intense, but the empathy could also be more subtle. A flysheet of 1631 by Andreas Bretschneider contains an etching in which Europa stands on a socle, deploring the state of war in Germany (illus. 113). Behind her is a split panorama: on the right, the soldiery roam around in a dark, stormy landscape, while on the left a sunny prospect opens from the plain. The etching does not reveal which sphere will triumph, but the text itself concludes optimistically: 'When sunshine comes the clouds must go, and where comfort has come the pains must cease'.[181] That sun-rays are comforting and clouds painful, that the former bring peace of mind and the latter despondency – such perceptions may need no historical support, but they can be sharpened by historical events. An example from 1779 illustrates the point. On two medals J. F. Stieler represents the state of Germany in 1778 and 1779 (illus. 114). The fact that Germany, recently at war, has been transformed into a flourishing land is demonstrated not only by the restoration of a broken column and the removal of the instruments of war, but by the transformation of a bare, empty agrarian landscape, with army tents on the horizon, into one filled with ploughmen, trees and sheep, and by the fact that church towers once more dominate the horizon.[182] During the Enlightenment the contrast between fine and stormy weather did not necessarily signify the light of knowledge in contention with ignorance. In the figure-scene of an allegory of war and peace F. G. Ménageot places the female spirits of peace prominently on a socle, crowning a naked youth with laurels, while Mars and Athena, with the slain dragon at their feet, finally desist from war (illus. 112). Yet the situation in the background is far from clear: the sky is almost completely enveloped in storm-clouds; only in the distance, beyond the mountains, are rays of light to be seen, suggesting that what has been agreed in the foreground may yet become reality. Ménageot, it seems, wished to contrast state actions, which are highlighted in the foreground and recorded by eager spirits in history books and treaties, with the conditions prevailing in the real world.[183]

The juxtaposition of a peaceful and a stormy landscape became quite unequivocal in the field of political propaganda, as in a British poster from the Great War, which uses conventionally contrasting landscapes to illustrate the German and British notions of a route to peace (illus. 115).[184] A French poster for a film of Tolstoy's *War and Peace* raises

what had formerly been background motifs to the status of universal principles, as if the war treated in the film were simply a chance manifestation of a general law (illus. 116). On the other hand, an SPD election poster of 1924, designed by K. Schulpig, holds fast to the contrast (illus. 117): the cornfield on the left, the realm of peace, is separated by a vertical bar from the realm of war, represented by the cloud of smoke from the exploding grenade. The cornfield is protected until the smoke blows over.

The sun too was invested with religious significance, as the light of truth and justice,[185] but the image of the sun could also represent moral concerns: suppressed passions could be expressed by the sun's rays caught up in clouds. The beloved, hopes for the future, a new century – anything that struck a positive note – might be likened to the sun. When Rubens wrote in 1627 that the calumny provoked by his visit to London 'si dissipò finalmente come la nebbia al sole', he was evidently thinking in terms of emblems, in which the sun stands for truth, clouds and mists for falsehood.[186] Starting from here, it was possible to invoke the sun as a beacon for countless programmes of enlightenment (illus. 118, 119).

For the ancient Egyptians the sun was an object of political adoration. In 1522, on Dürer's triumphal chariot for Emperor Maximilian, the popular motto appears: 'Quod in celis sol hoc in terra imperator'.[187] Long before Louis XIV had monopolized the sun, it had been employed as a symbol of rule, especially to demonstrate sovereignty.[188] In the early seventeenth century the sun looks out from gold coins issued by the Gonzagas in Mantua, while the motto states that this is no borrowed splendour (illus. 120).[189] Queen Christina of Sweden, in deliberate opposition to Louis XIV, had her likeness placed in the orb of the sun and proclaimed in the motto that it was not a question of false or foreign feathers (illus. 121).[190] Napoleon, too, favoured this combination of the sun with the face of the ruler (illus. 122).[191] The rigid heraldic symbols were thus no longer bound to a fixed context. In 1667, on a medal by Jean Mauger, Louis XIV is portrayed as the sun above the globe, under the motto 'Nec Pluribus Impar' (illus. 124). The image of the monarch as a world ruler appealed to Napoleon too.[192] Such extensions introduce a historical dimension into the iconography, allowing it to relate to particular events, and quite new meanings can be conveyed

through slight shifts in the configuration. An Austrian medal polemicizes against Louis XIV by just such a shift: the sun now disappears behind the globe – implying that Louis's power is sinking (illus. 123). In 1632 the death of the King of Bohemia had been represented in the United Provinces by a setting sun (illus. 125) – a precedent that lent a sinister connotation to the Austrian polemic.[193]

When once the sun is used to make a political statement in narrative or landscape contexts, a political discourse ensues that can always be slightly modified, reversed or extended.

The fact that the sun casts shadows may suggest a threat. A device of the Milanese commander Giovan Jacopo Trivulzio, made after Ludovico Sforza dismissed him from his service, shows a broad, open landscape and a smiling sun, but in the foreground is a marble slab; a spear-point sticks out of it, casting a sharp shadow on the marble (illus. 126). The motto, 'Non cedit umbra soli', means 'Just as the shadow never yields to the sun, but always stands behind him on whom it shines, so I, Trivulzio, will always be at your heels, Sforza!' A simple physical phenomenon thus reinforces a banal claim to power.[194] Also in Milan, a portrait medal was struck in honour of the Duke of Terranuova. The reverse shows the sun over the sea. According to the motto, this signifies that a true prince who reveals all his riches, and so exposes them to the sun, will never see them diminished (illus. 128).[195]

In the landscape painting of the time such motifs as the sun over the sea or a plain were hardly common as independent pictorial themes. It is conceivable that their use in political contexts promoted the independent landscape or genre scene, and that interest in landscape painting was aroused by such interpretative possibilities.

About 1615 Maximilian I of Bavaria issued a coin on which the sun shone over the region around Munich, no doubt signifying Maximilian's favour towards his country (illus. 127).[196] It does not follow that every pictorial treatment of this theme was meant to convey the same sense, yet it is important to know that it could have been thought to. If it was possible, in 1609, for a town to compare the return of the king and queen within its walls to the sun dispersing the mist,[197] then any landscape picture that employed the same motif might be construed in the same way, even if no such construction was intended. In this case a competing allegory of envy would be

possible, or, as happened after the Peace of Westphalia in 1649, the celebration of a peace that had dispersed the dark clouds of war.[198] In 1674 the Dutch could use the same image in an etching directed against the French monarch: just as the sun can chase away the clouds, so the lion of the United Provinces can chase away the Gallic cock.[199] The negative interpretation of clouds was clearly so common that Claude Lorrain provided a drawing of clouds with a note to the effect that this bank of clouds had been interpreted as a meeting between two warriors (illus. 130, 132).[200] As early as 1546 a medal had been struck for the Florentine *condottiere* Giovanni delle Bande Nere; on the reverse, a flash of lightning issues from a bank of clouds; this was meant to illustrate his principle of war (illus. 129).[201] It is probably the first known 'cloud picture' and may help us to understand why Carl Rottmann, about 1849, painted the battlefield of Marathon as a pure cloud picture (illus. 131). This was a

> coded statement about contemporary events. The battle between the Persians and the Greeks, so decisive for western civilization, is reflected in the distribution of the cloud masses. . . . The earth is destroyed by the storm, and elemental forces are unleashed, symbolized by the racing horse and the lightning. The situation in Munich in 1848, the popular uprising, the revolt against the ruler, and his feeling that he had a mission to uphold monarchic tradition and western culture are here projected on to the historical landscape.[202]

The historical landscape was clearly a 'political landscape' after all, as Förster back in 1849 seems to have guessed.

On consulting the handbooks on emblems, we find that there is hardly any political situation that cannot be elucidated by comparisons with the sun: a simple sunny landscape could be drawn into an argument, as it is by the authors of a *Political Treasury* of c. 1627: 'As the sun stands in the sky and rises over rich and poor, so let the ruler be no respecter of persons but settle the cause justly'.[203] Similarly J. W. Zincgref, in his *Emblematum ethico-politicorum Centuria* (first printed in 1619), interprets an etching of a river valley that at sunrise still lies half in the shadow of night (illus. 134) in the following terms: 'Prince, let your mercy reign everywhere, as far as your eye can see'.[204] The same sunrise, on a silver medal issued in

Anhalt-Köthen in 1755, could signify the hopes attending the accession of Carl Georg Leberecht (illus. 133).[205]

Naturally the sun indicates that the prince is an image of God. Royal virtue, like the sun, gives pleasure to all in the kingdom. The prince is to his realm what the sun is to the sky or the heart to the body: a bestower of warmth. And just as the sun goes on shining behind the clouds, so does the mind of the prince in times of misfortune. As plants turn to the sun, so the courtiers turn to the prince.[206]

The sun could thus be invoked for a great variety of comparisons, but in individual cases its meaning was unambiguous. It is only in the Romantic period that we find ourselves wondering, for instance, whether Caspar David Friedrich's *Woman in the Morning Sun* is to be interpreted in Christian, political or sentimental terms – or not at all.[207] The uncertainty is of course due less to a taste for ambiguity than to the fact that easel painting had ceased to be a suitable medium for political and public statements and was no longer used for this purpose; interpretation could therefore be left to personal whim. In the less artistic political imagery of the nineteenth and twentieth centuries, however, the image of the sun remains unequivocal, as in the May Day iconography of trades unions and socialist parties, for which 'The New Day' was proclaimed in 1904 by a sunrise with Phoebus Apollo (illus. 137).[208] And it would be almost amazing if Félix Vallotton's *Sunset* of 1917 had no bearing on the Great War (illus. 135).[209] In the October Revolution the connotation of the 'sun of freedom' was so exclusive that it could already be treated abstractly, as in David Sterenberg's design of 1918 (illus. 136).[210] In 1932 no text was needed to explain to German women what was implied by the swastika in the sun (illus. 138).[211]

Though the sun was a favourite landscape element in political symbolism, it was not the only one. There was hardly any object in the landscape, hardly any landscape activity – the rainbow, the oak and other trees, the sunflower, ruins, rivers, woods, agricultural pursuits (those of the farmer,[212] the carter, the shepherd), the behaviour of bees or ants[213] – that could not be exploited politically. Quite recently attention has been drawn to the many contrasts between palace and cottage, a *leitmotiv* in landscape painting.[214]

In his essays Francis Bacon employs various landscape

images when enjoining the ruler to be circumspect in dealing with unruly forces: 'Shepherds of people had need know the kalendars of tempests in state; which are commonly greatest when things grow to equality, as natural tempests are greatest about the *Aequinoctia*. And as there are certain hollow blasts of wind and secret swellings of seas before a tempest, so are there in states.'[215] We need not construe each of the countless seventeenth-century storm pictures as a political allegory, but if Bacon himself could read a political warning into the 'secret swellings of seas before a tempest', this shows that even his scientifically inclined mind could relate the observation of natural phenomena to political conditions.

Francesco Guicciardini certainly did not have an easy time as papal governor of the turbulent city of Bologna. It is therefore understandable that he should have wished to announce this in 1529 by having his own medal struck (illus. 140). On the reverse he sums up his situation in the simple formula 'A Rock in the Storm'. This formula is easily pronounced, but less easily turned into a metaphor: in the absence of any literary support, a mere seascape with a rocky hill in the middle was not yet a familiar image. The unknown medalist pleasingly accommodates the two natural elements to the round format, though the rock seems to be floating rather than standing.[216] It became common to associate this image not only with loyal servants and ministers, but also with princes. Wenzel Hollar used it to symbolize the sufferings of Charles I before his execution (illus. 139). In the right half of the picture the King kneels piously in front of books and the crown of thorns; on the left a storm rages over the sea, in which a rock stands unshakable; in the foreground a board with weights presses down on one of the palm-trees, indicating that 'under pressure virtue only grows'.[217] In 1761 Queen Louisa Ulrica of Sweden expressed her opposition to the Swedish parliament's decision to wage war on her Prussian brother in the image of waves beating in vain against an unshakable rock (illus. 141).[218] In 1806 a medal was struck in memory of William Pitt; the reverse showed a rock in a stormy sea (illus. 142).[219] The same statement was only slightly extended when a lighthouse was added to the rock, as on a medal for Michel de l'Hôpital, the chancellor of France (illus. 143).[220] In general, stormy weather could appear as a threat to the state;[221] it could also point to the dangers of court life,[222] or

to the people, who in restless times could be likened to 'the sea threatening the cliffs'.[223] The following passage from Machiavelli could be read as an instruction to a landscape painter (if pure landscape painting had existed at the time):

> I would liken the power of Fortune to a raging river, which, when it wildly overflows, floods the fields, tears down trees and houses, and sweeps away earth in one place, to deposit it in another.... But the river's rage does not prevent men from taking precautions, in times of peace, by building dams and dikes, so that when the waters erupt they are led off through a canal and their onslaught is less overwhelming and dangerous. So it is with the power of Fortune...[224]

Another favourite image of resistance was the tree in a storm: it showed either that it is possible to be pliant in stormy times or to be steadfast and resistant (illus. 145).[225] On the other hand a broken bough, the victim of a storm, points to civil wars and past perils (illus. 147).[226] Hence we need not relate the drawing of a broken tree-trunk by Poussin or Rubens to the revolutionary movements of the age, though both were keenly aware of them (illus. 146). Yet one may wonder whether Poussin would have taken so much interest in the detail of such a motif, had he not thought that it could be exploited one day as a symbol. Shakespeare describes the state of England as a garden, but one that

> Is full of weeds; her fairest flowers chok'd up,
> Her fruit-trees all unpruned, her hedges ruin'd,
> Her knots disorder'd, and her wholesome herbs
> Swarming with caterpillars ...[227]

While not obliged to construe every corresponding landscape picture as an analysis of conditions in the state, we can nevertheless sharpen our perception of the natural objects seen in paintings if we know that such connotations were possible. In Nuremberg in 1688 it was said: 'Just as the clouds soar aloft, one above the other, then pour down fruitful rain, by which field, fruits and men are refreshed and quickened, so in matters of virtue a noble mind must climb aloft and strive to serve his country with his gifts'.[228] We need not discern an injunction to virtue in every picture of rain, but we may still wonder whether the attention paid in pictures to such an

everyday occurence as rainfall did not have special significance for the artists and their public (illus. 144).

In 1609, when a truce was finally agreed between the United Provinces and the Spanish Netherlands, a medal was struck (illus. 148). One face showed a ship on a calm sea that, according to the motto, the seafarer had reached after a storm. On the other was a woman milking a cow, signifying, according to the motto, that the hungry or the greedy offered the farmers a secure future. The sense is clear: shipping and agriculture will flourish in the new conditions of peace.[229]

Hoping that the peace would have favourable results, Rubens quickly returned from Italy to Antwerp. During the twelve-year truce he painted his first landscapes, in many of which women are seen milking cows. The *Polder Landscape* (illus. 150) in Munich presents a self-sufficient world where all collaborate in farming activities. In the foreground a farmer in a red jacket pours milk into a jug held out by his wife. The viewer's gaze is drawn to the left, away from this world of active give and take, past the farmsteads and towards the evening horizon, then through turbulent clouds to the sky; it returns to the middle ground, where birds fly before dark clouds. In a patch of woodland shaded by a high wall of trees the departing sunlight is caught in the dense branches. A dark area of ponds and swamps remains, the trees dimly reflected in the still water. On the right the old willow-stumps, withered and split, seem to complain. The composition echoes the original dichotomy of the Venetian landscape – peace on the left, darkness and foreboding on the right. As men and women go about their evening tasks, the creatures of the wild react to a change in the weather that is felt in the air. The mood of this landscape seems to be determined by the precarious peace. We scarcely need reminding of the medal, still less of the use of a split tree-trunk as a metaphor for a split or dying state (illus. 147).[230] The emblematists inform us that a bird above dark clouds (illus. 149) signifies flight from the storms of Fortune. Seen in this way, the birds and the clouds in Rubens's picture would mean exposure to the storms of Fortune, while the still water might signify the peace of mind that is called for in such conditions.[231] The picture does not require all this preliminary knowledge; its natural mood need not be linked with the political mood of the times. Yet such

knowledge does not make it flat or invalid; indeed, it adds an extra dimension, combining human experience with the experience of nature.

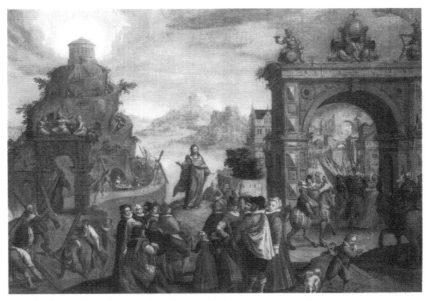

107 Circle of Gillis Mostaert, *The Broad and Narrow Ways*, c. 1580.

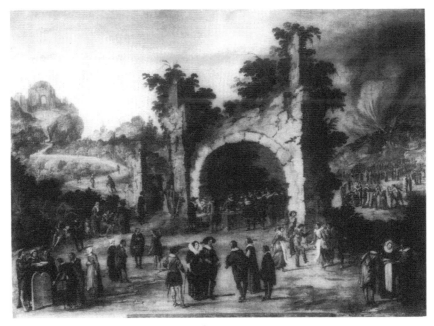

108 Govert Jansz., *The Narrow and Broad Ways* c. 1600.

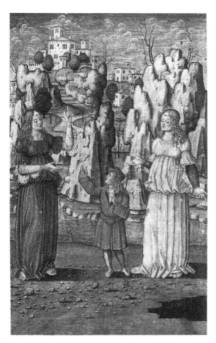

109 Milanese miniature showing
Massimiliano Sforza choosing between
Virtue and Vice, *c.* 1496.

110 Jan Sadeler the Elder, Prince
Maximilian of Bavaria as Hercules at the
parting of the ways, 1595.

111 Giovanni Cariani, *Fortuna between Natura and Musica, c.* 1515.

112 François Guillaume Ménageot, *Allegory of War and Peace*, 1805.

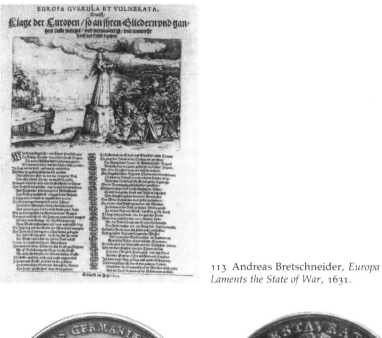

113 Andreas Bretschneider, *Europa Laments the State of War*, 1631.

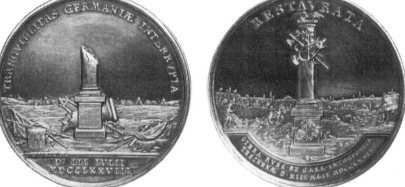

114 J. F. Stieler, *The German Peace Interrupted, and Restored*; both sides of a medal struck in 1779.

115 British poster of c. 1917 illustrating German and British aims.

116 A French poster for Bondartchouk's 1965 film of Tolstoy's *War and Peace*.

117 A 1924 poster for the German Social Democratic Party inviting voters to choose between peace and war.

118 Daniel Chodowiecki, *Enlightenment*, 1791.

119 Robert Guillaume Dardel, *Descartes Cuts through the Clouds of Ignorance*, 1782.

120 Gaspare Molo, Coin comparing Ferdinand Gonzaga, Duke of Mantua, to the sun, 1615.

121 Soldani's medal showing ex-Queen Christina of Sweden as the sun, (?) after 1660.

122 Laurent Dabos, Napoleon within a laurel wreath and sunlight, 1806.

123 J. W. Zincgref, emblem, showing the King as the Sun, 1619.

124 Jean Mauger, medal of Louis XIV as the sun, 1667.

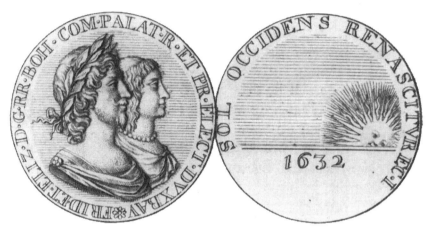

125 Dutch engraving after a medal following the death in exile of the King of Bohemia, 1632.

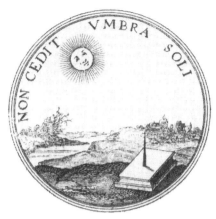

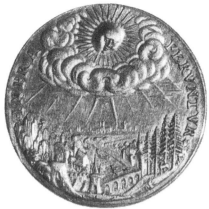

126 Giovan Jacopo Trivulzio, a device after Typotius's *Symbola* . . . (Prague, 1601/03).

127 Gold alms money showing the blessings of the rule of Maximilian I of Bavaria, *c.* 1615.

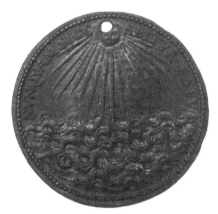

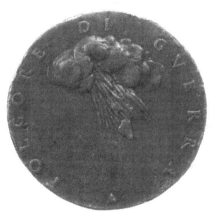

128 Pier Paolo Galeotti, Sun over the sea, from a medal of Tommaso Marino, Duke of Terranuova, *c.* 1552.

129 Medal, after Danese Cattanneo, for Giovanni delle Bande Nere, with lightning from a cloud, *c.* 1546.

130 Claude Lorrain, drawing of clouds over Genoa, 1626/7.

131 Carl Rottmann, *The Battlefield of Marathon*, c. 1849.

132 Claude Lorrain, drawing of a cloud seen as an omen of war, 1624.

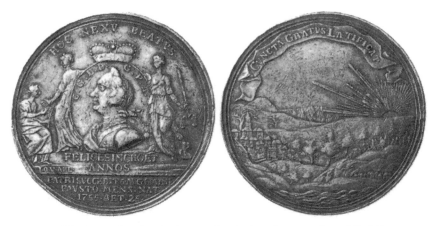

133 A medal of 1755 showing the hopes attendant on the accession of Carl Georg Leberecht of Anhalt-Köthen.

134 J. W. Zincgref, emblem, showing the prince's favour, 1619.

135 Félix Vallotton, *Sunset*, 1917.

136 David Sterenberg, panel design of the Sun of Liberty, 1918.

137 F. Stassen, *The New Day*, 1904, May Day news-sheet.

138 Wolf Willrich, poster for the National Socialist Women's Movement, 1932.

139 Wenzel Hollar, The steadfastness of Charles I of England before his execution, 1649.

140 A medal of 1529 for Francesco Guicciardini, showing the Governor as a rock in the storm.

141 A medal for Queen Louisa Ulrica of Sweden, showing the waves beating in vain against the rock, 1761.

142 A medal in memory of William Pitt the Younger, showing a rock in stormy sea, 1806.

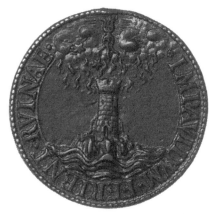

143 A medal for Michel de l'Hôpital, showing a tower on a rock in the sea, struck by lightning, c. 1565.

144 Engraving after a medal showing the entry of Maria Theresa into Paris as rain falling onto parched ground, 1660.

145 A 1630 double-thaler of Hessen-Kassel, showing endurance in hard times: a tree bowed over in the storm.

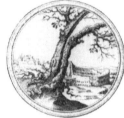

146 Nicolas Poussin, drawing of a broken tree-trunk, c. 1629.

147 An emblem from Buck's *Emblemata Politica* of 1618, showing a split tree.

148 Engraving after a medal commemorating peace in the Low Countries, 1609.

149 *Natura Dictante Feror*, emblem from Camerarius's *Symbolorum* of 1596.

150 Peter Paul Rubens, *Polder Landscape with Cows*, c. 1621.

Conclusion

There was a time when we liked to think of landscape as something that compensated us for a loss. In it we sought what was no longer ours by right. It was a refuge for the civilized, in which they could experience what was missing, suppressed or forgotten in the economic, social or private world they inhabited. Landscape could be deliberately sought as an ideal destination only when human life was no longer led in natural landscape conditions.

However much nature was disguised or conceptually predefined at any given period, she remained a true and genuine authority, to which norms of behaviour had to conform if they were to be humane. Religion and ideology constantly sought to gain a monopoly on nature, but this would have been futile, had not the rest of her authority remained intact and ready to be pressed into service.

As for the field of political imagery that we have examined here, it has emerged that landscape enters into a partnership with the man-made elements imposed on it, to which it must visibly relate. Boundary stones, roads and monuments convey certain meanings, and these demand certain statements from the landscape. Castles not only use topographical features for practical purposes, but call for mental attitudes. In wartime the landscape becomes increasingly helpful as a partner, until it becomes clear that it could also cease to be a partner at all. In gardens, too, landscape was assimilated to human reason, but even when the purpose was educative, it was pursued by natural means, which even the landscape garden used didactically. Natural giantism seeks to unite the great individual with the landscape in a grandiose monumental form, so that he will appear superhuman and overwhelming. The ruler may be portrayed as controlling the forces of nature; alternatively he may appear as the distributor of her gifts and so confirm her superior status.

The painted landscape is commonly thought to have emerged in a situation in which 'landscape is nature viewed aesthetically, free of any association with science, work and

action, as the correlate of nature as an object of scientific study, appropriated by society in the world of work and action'.[232] According to this view nature would survive only as an aesthetic construct. Yet here too we have seen her exposed to a great variety of interpretations: panoramas may express a wish for co-ordinated forms of communication, rugged massifs may reflect the fear of insurmountable obstacles. Above all, topographical features have repeatedly been called in aid as political metaphors. Yet it would be correct to say that the natural connotation must be kept alive if the message is to retain its force. The semantic and optical exploitation of the landscape may make it appear alien and instrumentalized, yet it seems to me undeniable that such exploitation only confirms its autonomous force and authority. If governments or power structures felt secure in terms of natural law by demonstrating their conformity with nature, this may have been a misjudgement, but at the same time the misjudgement reinforced the normative value of such conformity and sharpened the perception of it.

It is therefore likely that the ability to see, paint and study nature *qua* nature grew in proportion to its usefulness to men's interests.

It is no longer possible to contrast an innocent landscape with an alienated humanity. The landscape can no longer be so naïvely delimited. Hardly anyone with his wits about him can now wander through the landscape, bathe in the sea or ramble through field and forest without scenting the poisonous sewage in the seaweed and roots, the exhaust fumes in the wilting leaves, the lethal pesticides in the blossoms. The landscape is so saturated by the toxins of civilization that it has been forced out of its former role and into a new one: it no longer compensates for civilization, but raises it to a higher power.

Man's devastating exploitation of nature has put an end to her argumentative force and autonomous authority. Permeated by foreign substances and marked out for destruction, she may still elicit sympathy and inspire relief measures, but she can no longer assist us by furnishing arguments for legitimacy. The rich reservoir of motifs and experiences that once guided human action, and that I have tried to record here, has run dry.

References

1 W. Sauerländer, 'Die Jahreszeiten. Ein Beitrag zur allegorischen Landschaft beim späten Poussin', *Münchener Jahrbuch der Bildenden Kunst*, VII (1956), pp. 169–84. W. Wiegand, *Ruisdael-Studien. Ein Versuch zur Ikonologie der Landschaftsmalerei*, diss., Hamburg, 1971. See also H. Kauffmann's interpretation of a single work, 'Jacob van Ruisdael "Die Mühle von Wijk bei Duurstede"', *Festschrift Otto von Simson. Zum 65. Geburtstag* (Berlin, 1977), pp. 379–97.

2 On the crossroads as a magic location see Klein, 'Kreuzweg', *Handwörterbuch des deutschen Aberglaubens*, v (Berlin and Leipzig, 1932–3), cols. 516–29. On the miniature of the Limbourg brothers cf. M. Meiss, *French Painting in the time of Jean de Berry: The Limbourgs and their Contemporaries* (New York, 1974), I, p. 195ff.

3 H. Boockmann, *Die Stadt im späten Mittelalter* (Munich, 1986), p. 14; H. Scharf, *Kleine Geschichte des Denkmals* (Darmstadt, 1984), p. 60f.; another example from Wiener Neustadt, *ibid.*, p. 64. Further examples are given by F. Zoepfel, 'Bildstock', *Reallexikon zur Deutschen Kunstgeschichte*, II (Munich, 1948), col. 701f. Cf. also the exhibition catalogue *Das Hochkreuz bey Godesberg* (Rheinisches Landesmuseum, Bonn, 1983).

4 G. Köbler, *Bilder aus der Deutschen Rechtsgeschichte* (Munich, 1988), p. 52.

5 E. Steingräber, *Zweitausend Jahre europäische Landschaftsmalerei* (Munich, 1985), p. 11.

6 H. Schwenkel, 'Die moderne Landschaftspflege', *Studium Generale*, III/4–5 (1950), p. 239.

7 W. Rösener, 'Flur', *Lexikon des Mittelalters* (Munich/Zurich, 1989), IV, col. 598f.

8 T. Breuer, 'Land-Denkmale', *Deutsche Kunst- und Denkmalpflege*, XXXVII (1979), p. 12.

9 *Die Kunstdenkmäler in Baden-Württemberg: Rems-Murr-Kreis*, compiled by A. Schahl (Munich, 1983), II, p. 1332.

10 M. Schwind, *Landschaft und Grenze* (Bielefeld, 1950), p. 8. A survey of the relevant research is given by H. Jäger, *Entwicklungsprobleme europäischer Kulturlandschaften* (Darmstadt, 1987) p. 125ff. Cf. A. Lüdtke and H. Medick, *Sozialwissenschaftliche Informationen*, 3 (1991), which is wholly devoted to the various aspects of the frontier.

11 Einhard, *Vita Karoli Magni*, cap. 7.

12 O. Maull, *Politische Grenzen* (Berlin, 1928), p. 5ff.; U. Ante, *Politische Geographie* (Braunschweig, 1981), p. 104ff.

13 Catalogue *Prag um 1600* (Essen, 1988), pl. 39, with pendant in the Landesgalerie, Hanover.

14 From N. Chomel, *Die wahren mittel länder und staaten glücklich, ihre beherrscher mächtig, und die unterthanen reich zu machen . . .* (Leipzig, 1750–59), cited by J. and W. Grimm, *Deutsches Wörterbuch* (Leipzig, 1935), IV, I.6, col. 177; see entry on 'Grenzsäule'.

15 *Die Kunstdenkmäler in Baden-Württemberg: Stadtkreis Mannheim*, rev. H. Huth (Munich, 1982), II, p. 1520.

16 *Die Kunstdenkmäler von Bayern: Regierungsbezirk Schwaben*, v: Stadt- und Landkreis an der Donau, compiled by A. Horn and W. Meyer (Munich, 1958), p. 637.

17 Scharf (see note 3), ill. pl. 35.
18 Catalogue *Freiheit, Gleichheit, Brüderlichkeit* (Nuremberg, 1989), no. 115; the watercolour in the Goethe Museum, Düsseldorf, removes the contradiction that the monarchic symbols stand over France and that the stake is also a signpost to Paris. Cf. S. Holsten in catalogue *Goya. Das Zeitalter der Revolutionen 1789–1830* (Hamburg, 1980), no. 325.
19 Ante (see note 12), p. 104.
20 Breuer (see note 8) has sketched the relevant thematic field. He names the areas left uncultivated, the fish culture, the wine-growing landscape, the milestones, resting stones, canals, aqueducts, mills and weirs, the high-tension cables, the defence areas transected by ditches; the 'governmental landscape' and the 'cult landscape', marked by stations of the cross or routes and places of pilgrimage.
21 Cf. Jäger (see note 10), p. 107ff. from the point of view of cultural geography. On Roman roads cf. H.-C. Schneider, *Alt-Strassenforschung* (Darmstadt, 1982). See also G. Germann, 'Krumme Strassen', *Zeitschrift für Stadtgeschichte und Stadtsoziologie und Denkmalpflege*, 1 (1976), pp. 10–25.
22 F. von Seidler, 'Fritz Todt', in R. Smelser and R. Zitelmann, eds, *Die braune Elite* (Darmstadt, 1989), p. 302f, denies that Hitler built the autobahns for military purposes. See also K. Arndt, 'Denkmaltopographie als Programm und Politik' in E. Mai and S. Waezoldt, *Kunstverwaltung, Bau- und Denkmal-Politik im Kaiserreich* (Berlin, 1981), pp. 165–90; on p. 188, n. 11 it is noted that the autobahn was celebrated in National Socialist propaganda as a 'symbol of German unity', just as the canals had been in the nineteenth century. J. Siedentop, 'Wandlungen im neuzeitlichen Strassenbild', *Zeitschrift für Erdkunde*, IV (1936), p. 301, states that the autobahns are 'undoubtedly to be viewed in their totality as a work of art'.
23 Cf. G. Ortenburg, *Waffe und Waffengebrauch im Zeitalter der Einigungskriege*, Heerwesen der Neuzeit, part IV, vol I (Koblenz, 1990), p. 195f.
24 Breuer (see note 8), p. 19.
25 J. Traeger, *Der Weg nach Walhalla* (Regensburg, 1987), p. 135. Cf. also W. Sasse, 'Wege und Meilensteine weisen nach Berlin', *Edwin Redslob zum 70. Geburtstag. Eine Festgabe* (Berlin, 1955), pp. 357–70.
26 H. Keller, 'Denkmal', *Reallexikon zur Deutschen Kunstgeschichte*, III, col. 1279; Scharf (see note 3), p. 98f.
27 Cf. E. F. Bange, *Die deutschen Bronzestatuetten des 16. Jahrhunderts* (Berlin, 1949), p. 55, and the catalogue *Renaissance in Österreich* (Schloss Schallaburg, 1974), no. 270. Numerous examples of roadside monuments from the decades around 1800 are listed by Traeger (see note 25), p. 136ff.
28 Cf. the exhibition catalogue *Der Ludwig-Donau-Mainkanal* (Nuremberg, 1972). Ludwig pursued the plans simultaneously and in ideological association with the Walhalla; see Traeger (see note 25), p. 127f.
29 Cf. E. Maschke, 'Die Brücke im Mittelater', in M. Warnke, ed., *Politische Architektur in Europa* (Cologne, 1984), pp. 267–95; H. Tintelnot, 'Brücke', *Reallexikon zur Deutschen Kunstgeschichte*, II (Stuttgart, 1948), cols. 1228–60.
30 F. Winzinger, *Wolf Huber. Das Gesamtwerk* (Munich/Zurich, 1979), no. 94. Dated 1542, Kupferstichkabinett, Berlin, 8491/200–1917.
31 Herzog Anton Ulrich Museum, Braunschweig, inv. no. 1454; see the catalogue *Zauber der Medusa* (Vienna, 1987), no. VIII/5.
32 Huber's drawing of a landscape with bridges in Munich (from 1515) is reproduced by Winzinger (see note 30), no. 42, where the dependency on Altdorfer is pointed out.

33 F. W. H. Hollstein, *Dutch and Flemish Etchings, Engravings and Woodcuts* (Amsterdam, 1949–), xxii, no. 264. Already seen in 1501/1505 in an illustration in P. Olearius, *De fide concubinarum*, published in Basle. Cf. M. Trudszinski, 'Von Holbein zu Brueghel', *Niederdeutsche Beiträge zur Kunstgeschichte*, xxiii (1984), p. 74.

34 *Neue Pinakothek: Erläutrungen zu den ausgestellten Werken* (3rd edn, Munich, 1981), p. 29, no. L. 1039. A 'religious dimension' is discerned by H. Börsch-Supan in the exhibition catalogue *Carl Blechen* (Berlin, 1990), no. 60.

35 This and other information is given by D. Hennebo, *Entwicklung des Stadtgrüns von der Antike bis in die Zeit des Absolutismus* (2nd edn, Hanover and Berlin, 1979), p. 90.

36 *All the Paintings of the Rijksmuseum* (Amsterdam, 1976), no. A 2699, p. 590; for a mirror-image copy, attributed to Adriaen van de Venne, in the Kunsthalle, Hamburg, see the catalogue *Alte Meister* (Kunsthalle Hamburg, 1966), 169, no. 182, where it is surmised that the castle in question is that of Heemskerck.

37 Quoted by A. von Buttlar, *Der Landschaftsgarten* (Cologne, 1989), p. 208.

38 Staatsgalerie, Stuttgart, inv. no. 360; cf. the catalogue *Alte Meister* (Stuttgart, 1962), p. 103, where it is stated that the picture is incorrectly signed 'M. Hobbema' on the lower left. On the possible models for Hobbema's avenue cf. M. Imdahl, 'Zu Hobbemas Allee von Middelharnis', *Festschrift K. Badt* (Berlin, 1961), p. 178; W. Stechow, *Dutch Landscape Painting of the Seventeenth Century* (2nd edn, London, 1968), p. 32f, and P.C. Sutton, *Masters of 17th-Century Dutch Landscape Painting*, exhibition catalogue (Amsterdam, Boston, Philadelphia, 1987–88), no. 47.

39 According to N. MacLaren, *National Gallery Catalogues: The Dutch School* (London, 1960), no. 830, p. 165ff, the council of Middelharnis bought the picture in 1783 from the estate of a municipal official; it may originally have been connected with an official municipal occasion.

40 Examples in Keller (see note 26), col. 1261; Scharf (see note 3), p. 47.

41 Keller (see note 26), col. 1267.

42 *Die Kunstdenkmäler von Bayern: Regierungsbezirk Schwaben*, vii: Landkreis Dillingen an der Donau, compiled by W. Meyer (Munich, 1972), p. 680.

43 Keller (see note 26), col. 1263, with further examples.

44 The Latin quotation is taken from the *Chronica major* of Matthaeus Parisiensis, cited by Keller (see note 26), col. 1269.

45 Cf. L. Titel, 'Monumentaldenkmäler von 1871 bis 1918 in Deutschland', E. Mai and S. Waezoldt, eds, *Kunstverwaltung, Bau- und Denkmal-Politik im Kaiserreich* (Berlin, 1981), p. 218f.

46 *Die Kunstdenkmäler von Bayern: Regierungsbezirk Oberfranken* II: Landkreis Pegnitz, compiled by A. Schädler (Munich, 1961), 321.

47 Cf. G. Germann, 'Frühe Nationaldenkmäler', *antithese* 1972/2, p. 45.

48 M. Arndt, 'Das Kyffhäuser-Denkmal', *Wallraf-Richartz-Jahrbuch*, xl (1978), p. 78.

49 On this 'monument topography' cf. K. Arndt (see note 22).

50 On Schinkel cf. P. Bloch, 'Das Kreuzbergdenkmal und die patriotische Kunst', *Jahrbuch Preussischer Kulturbesitz* (Berlin, 1973), pp. 142–59.

51 Cf. V. Loers, 'Walhalla und Salvatorkirche. Romantische Architektur und ästhetische Landschaft im Vormärz', J. Traeger, ed., *Die Walhalla* (Regensburg, 1979), p. 75. On the idea of pilgrimage cf. M. Stuhr, 'Das Kyffhäuser-Denkmal', K.-H. Klingenburg, ed., *Historismus* (Leipzig, 1985), pp. 157–82. Traeger (see note 25) assigns a central role to this staged-managed approach to the monument and relates it to the attitudes of travellers. The aspect of pilgrimage is also emphasized by Arndt (see note 48), p. 78f.

52 On a similar dispute in 1910 when the competition for the Bismarck monument near Bingerbrück was advertised cf. Titel (see note 45), p. 244ff.

53 Traeger (see note 25), p. 179.

54 K. H. Clasen, 'Burg', Reallexikon zur Deutschen Kunstgeschichte, III (Stuttgart, 1954), cols 132, 134, 141.

55 Hans Sachs, Werke, ed. A von Keller, III (repr. Hildesheim, 1964), p. 244. Cf. also R. Fechner, Natur als Landschaft (Frankfurt, Berne and New York, 1986), p. 20ff, and M. Eberle, Individuum und Landschaft (Giessen, 1980), p. 24. On the view from the tower in courtly romance, where a quite unreal landscape is seen, cf. R. Gruenter, 'Zum Problem der Landschaftsdarstellung im höfischen Versroman', in A. Ritter, ed., Landschaft und Raum in der Erzählkunst (Darmstadt, 1975), p. 322ff. In 1502 the court painter Jörg Kölderer received a commission from Innsbruck to 'paint with landscape' (mit lantschaft abmallen) the counties of Friuli and Austria (which probably means the local castles): Jahrbuch der Sammlungen des Allerhöchsten Kaiserhauses, I (1888), reg. no. 230, also no. 831; this is the first attestation of the term Landschaft in connection with a painting.

56 O. Lehmann-Brockhaus, Lateinische Schriftquellen zur Kunst in England, Wales und Schottland vom Jahre 901 bis zum Jahre 1307, 5 vols (Munich, 1955–60), no. 416.

57 M. Warnke, Bau und Überbau (Frankfurt am Main, 1976), p. 90.

58 Catalogue Altkölner Malerei, Wallraf-Richartz-Museum, Cologne, compiled by F. G. Zehnder (Cologne, 1990), pp. 212–23.

59 In Leonardo's Last Judgment drawing of c. 1515 (Windsor 12380; see A. E. Popham, Leonardo da Vinci. Zeichnungen, Munich, 1928, no. 83 and p. 22) bosses from a castle wall seem to be involved in the catastrophic whirlwind; a burning castle also appears in the Last Judgment of Johann de Hemmessen, Antwerp (G. Kauffmann, Die Kunst des 16. Jahrhunderts, Propyläen Kunstgeschichte, VIII, Berlin, 1970, ill. 77).

60 Cf. U. Feldges, Die Landschaft als topographisches Porträt (Berne, 1980), p. 54f.

61 J. Paul, Die mittelalterlichen Kommunalpaläste in Italien, diss., Freiburg im Breisgau, 1963, p. 68ff.

62 Cf. A. Henkel and A. Schöne, Emblemata (Stuttgart, 1967), col. 1214; on the origin of the saying see M. Warnke, The Court Artist (Cambridge, 1993), p. 180.

63 Melone's picture is reproduced in B. Berenson, Italian Pictures of the Renaissance: Central Italian and North Italian Schools (London, 1968), p. 1670. Cf. Cranach's portrait of Dr Cuspinian and his wife (1502/3), Winterthur, and Bernhard Strigel's portrait of Maria Bianca Sforza (1505/10) at Ambras castle, in the catalogue of the picture gallery, Kunsthistorisches Museum, Vienna: Porträtgalerie zur Geschichte Österreichs von 1400–1800 (Vienna, 1982), no. 267.

64 H.-P. Baum, 'Burg', Lexikon des Mittelalters, II (Munich and Zurich, 1983), col. 971. On the other hand, W. Hardtwig, 'Soziale Räume und politische Herrschaft' (W. Hardtwig and K. Tenfelde, eds, Soziale Räume in der Urbanisierung, Munich, 1990, p. 62), maintains that 'in fact practically nothing is known about the relation between the architectural environment and social attitudes'.

65 A schematic castle is seen for instance on hilltops in the Agostino panel of Simone Martini (Siena, cathedral works), cf. Feldges (see note 60, ill. 11.

66 W. Braunfels, Mittelalterliche Stadtbaukunst in der Toskana (Berlin, 1953), pp. 25, 47.

67 Cf. H.-J. Raupp, 'Zur Bedeutung von Thema und Symbol für die holländische Landschaftsmalerei des 17. Jahrhunderts', *Jahrbuch der Staatlichen Kunstsammlungen in Baden-Württemberg*, xvii (1980), p. 92.

68 R. Paulson, *Literary Landscape: Turner and Constable* (New Haven and London, 1982), p. 45.

69 Cf. G. Hartmann, *Die Ruine im Landschaftsgarten* (Worms, 1981), pp. 304–12, and M. Schwartz, 'Fürst Johann von Leichtenstein und die romantische Landschaftsinszenierung im südlichen Niederösterreich', *Kunsthistorisches Jahrbuch Graz*, xxiii (1987), pp. 146–65. On Klenze's judgement of Donaustauf cf. Traeger (see note 25), p. 89.

70 On examples in Caprarola see L. W. Partridge, 'The Sala d'Ercole in the Villa Farnese at Caprarola', *Art Bulletin*, liv (1972), p. 50; on Stuttgart see H. Geissler, 'Zeichner am Württembergischen Hof um 1600', *Jahrbuch der Staatlichen Kunstsammlungen in Baden-Württemberg*, vi (1969), p. 91.

71 D. H. Solkin, 'The Battle of the Ciceros: Richard Wilson and the Politics of Landscape in the Age of John Wilkes', in S. Pugh, ed., *Reading Landscape* (Manchester, 1990), p. 34.

72 The Hague, Kon. Bibliotheek, Pamphlet 3139 (Knuttel 3139); single sheet with text. On the chain of conquests placed in oval form around Spinola by Georg Kress, 1620/21, see D. Alexander and W. L. Strauss, *The German Single-Leaf Woodcut: 1600–1700*, i (New York, 1977), p. 353.

73 Cf. G. Duby, *Der Sonntag von Bouvines 27. Juli 1214* (Berlin, 1988), pp. 112, 124.

74 W. Janssen, 'Krieg', O. Brunner, W. Conze and R. Koselleck (eds), *Geschichtliche Grundbegriffe*, ii (Stuttgart, 1982), p. 570. A. Broockmann, 'Fehde', *Lexikon des Mittelalters*, iv (Munich and Zurich, 1989), cols 331–34.

75 H. Delbrück, *Geschichte der Kriegskunst im Rahmen der politischen Geschichte* (photomechanical repr. of 2nd edition [1923], iii, Berlin, 1964), p. 157. Further examples *ibid.*, p. 419: in 1138 the English took up a position on a hill against the Scots. *Ibid.*, p. 454: in 1314 the Scots under Robert had 'added to the already very strong obstacle to their front formed by the deep, swampy river valley by digging hidden trenches on the slope leading up to his position'. Later the Hussites showed great skill in exploiting features of the terrain (*ibid.*, p. 503ff.). Before the battle of the Morgarten in 1315 the Swiss carefully reconnoitred the terrain and took advantage of the mountainous environment (*ibid.*, p. 581f).

76 *Ibid.*, p. 672.

77 *Ibid.*, iv, p. 82.

78 *Ibid.*, p. 339.

79 S. Fiedler, *Kriegswesen und Kriegführung im Zeitalter der Landsknechte*, Heerwesen der Neuzeit, part 1, vol 2 (Koblenz, 1985), p. 183.

80 *Ibid.*, p. 217, and U. Daniels, *Geschichte des Kriegswesens: Neuzeit*, part 2 (Leipzig, 1911), p. 70ff.

81 Fiedler (see note 79), p. 182f.

82 Cf. G. Goldberg, *Die Alexanderschlacht und die Historienbilder des bayrischen Herzogs Wilhelm IV. und seiner Gemahlin Jacobaea für die Münchener Residenz* (Munich, 1985), p. 10ff; Barbara Eschenburg, 'Altdorfers Alexanderschlacht und ihr Verhältnis zum Historienzyklus Wilhelms IV.', *Zeitschrift des Vereins für Kunstwissenschaft*, xxxiii (1980), esp. p. 38ff.

83 Fiedler (see note 79), ill. 82, p. 212.

84 H. M. Colvin, ed., *The History of the King's Works*, iv (London, 1982), p. 397.

85 U. Thieme and F. Becker, *Allgemeines Lexikon der bildenden Künstler von der Antike bis zur Gegenwart*, II (Leipzig, 1908), p. 35.

86 Cf. Warnke (see note 57), p. 214ff.

87 F. De Hollanda, *Vier Gespräche über die Malerei geführt zu Rom 1538*, ed. J. de Vasconcellos (Vienna, 1899), p. 89. Cf. also Ludovico Dolce, 'L'Aretino ovvero Dialogo della Pittura' (1557), P. Barocchi, ed, *Trattati d'arte del Cinquecento* I (Bari, 1960), p. 215.

88 S. Fiedler, *Kriegswesen und Kriegführung im Zeitalter der Kabinettskriege*, Heerwesen der Neuzeit, part 2, vol 2 (Koblenz, 1986), p. 201.

89 S. Fiedler, *Grundriss der Militär- und Kriegsgeschichte*, I (Munich, 1972–78), p. 287.

90 On Tintoretto cf. B. Berenson, *Italian Pictures of the Renaissance: Venetian School*, II (London, 1957), p. 1288.

91 Guillaume Baudart, *Les Guerres de Nassau* (Amsterdam, 1616), p. 89.

92 C. Justi, *Diego Velázquez und sein Jahrhundert*, II (3rd edn Bonn, 1923), p. 34.

93 Catalogue *Luister van Spanje en de belgische Steden* (Brussels, 1985), no. B38; p. 453.

94 On the preconditions and the tendency see S. Zurawski, 'New Sources for Jacques Callot's "Map of the Siege of Breda"', *Art Bulletin*, LXX (1988), pp. 622–39.

95 On the coloured engraving see the catalogue *Welt des Barock* (Augustiner Chorherrenstift St Florian 1986), no. 14.08.

96 How this cartographic approach to the landscape then shifts to a tourist approach to travel can be traced in the examples given by Traeger (see note 25), who cites a passage of Heine, written in 1824, describing how at the summit of the Brocken one has the feeling that the landscape presents itself 'like a sharply drawn, clearly illuminated map'.

97 Catalogue *Österreich zur Zeit Kaiser Josephs II.* (Melk, 1980), no. 66. A roughly contemporary painting by J. C. Frisch shows the Prussian General Seydlitz dismounting in the foreground to give instructions on the forthcoming battle of Rossbach to his cavalry, whom he had trained, both individually and as a troop, on the terrain; the troops march off amid ominous clouds of smoke: see the catalogue *Friedrich der Grosse* (Berlin, 1986), no. IV/23a.

98 F. M. Kircheisen, *Napoleon I. und das Zeitalter der Befreiungskriege in Bildern* (Munich and Leipzig, 1914), p. 209.

99 See Titel (note 45), p. 247 on the monument commemorating the Battle of the Nations in Leipzig.

100 G. Ortenburg, *Waffe und Waffengebrauch im Zeitalter der Kabinettskriege*, Heerwesen der Neuzeit, part 2, vol. 1 (Koblenz, 1986), p. 174.

101 G. Ortenburg, *Waffe und Waffengebrauch im Zeitalter der Einigungskriege*, Heerwesen der Neuzeit, part 4, vol. 1 (Koblenz, 1990), p. 200.

102 On Stuck see H. Voss, *Franz von Stuck* (Munich, 1973), no. 105/278.

103 On Meidner see the catalogue *Apokalyptische Landschaft* (Berlinische Galerie and Los Angeles, 1990). Interpreted as entelechy of the stylistic approach by O. Bätschmann, *Entfernung der Natur. Landschaftsmalerei 1750–1920* (Cologne, 1989), p. 203ff.

104 On Erler see F. von Ostini, *Fritz Erler* (Bielefeld and Leipzig, 1921), p. 128, ill. 118. Otto Dix used this motif for his war picture.

105 I. T. Schick, *Das Bilderlexikon der Uniformen von 1700 bis zur Gegenwart* (Munich, 1978), pp. 145f., 241f.; *The Encyclopedia Americana: International Edition*, V (Danbury, 1989), p. 291. On the involvement of artists see M. Scolari, 'La construzione dell' invisibile – Occultamento e camouflage nella guerra moderna', *Eidos*, VI (1990).

106 See the catalogue *Paul Klee: Das Frühwerk. 1883–1922* (Munich 1979–80), no. 256.

107 Dix's picture *Flanders* (1934–6) in the Nationalgalerie, Berlin (B 658); similarly *Gassed* by Gilbert Rogers, Imperial War Museum, London, 93819). Cf. the catalogue *Bismarck* (Berlin, 1990), no. L/40.

108 This can be clearly seen in the landscapes of Radziwill.

109 G. Allinger, 'Heimat und Landschaft in Edwin Redslobs Schaffen', *Edwin Redslob zum 70. Geburtstag* (Berlin, 1955), p. 196f.

110 Cf. G. Pochat, *Figur und Landschaft* (Berlin and New York, 1973), p. 207; other instances in Hennebo (see note 35), p. 41ff. The quotation is from Thomas Aquinas, *De regimine principum*, lib. 2, cap. 4.

111 Cf. R. Klibansky, E. Panofsky and F. Saxl, *Saturn und Melancholie* (Frankfurt am Main, 1990), p. 387.

112 H. Bredekamp, *Vicino Orsini und der Heilige Wald von Bomarzo* (Worms, 1985).

113 On this and what follows see Hennebo (note 35), p. 74.

114 *Ibid.*, pp. 74, 149, 153.

115 Y. Bottineau, 'Essais sur le Versailles de Louis XIVe', *Gazette des Beaux-Arts*, CXI (1988), pp. 77–98, 119–32. The opening of the Prater was recorded by J. H. Löschenkohl in an etching of 1781; cf. the catalogue *Maria Theresia und ihre Zeit* (Vienna, 1980), no. 40.22 with illustration.

116 Cited by Hennebo (note 35), p. 116.

117 A. von Buttlar (see note 37), p. 204; see also id., 'Der Garten als Bild – das Bild des Gartens. Zum Englischen Garten in München', in the catalogue *Münchner Landschaftsmalerei 1800–1850* (Munich, 1979), p. 164.

118 C. C. L. Hirschfeld, *Theorie der Gartenkunst* (5 vols, Leipzig, 1779–85, repr. in 2 vols, Hildesheim and New York, 1973). Sckell too saw the popular gardens as offering an opportunity for 'a meeting of the classes in the bosom of nature'. Cf. W. Rossow, *Die Veränderung des Landschaftsbegriffes in zwei Jahrhunderten*, Reihe der Bayerischen Akademie der Schönen Künste 18 (Munich, 1975), p. 12.

119 T. Dombart, *Der Englische Garten zu München* (Munich, 1972), pp. 40, 118.

120 Hirschfeld (see note 118), vol 5 (Leipzig, 1785), p. 70.

121 Both quoted by S. Gerndt, *Idealisierte Natur* (Stuttgart, 1981), p. 122f.

122 Schiller, first version of *Don Carlos* (Thalia-Fragment of 1785), quoted by Gerndt, p. 110.

123 See Hartmann (note 69), p. 78, for the quotation from Hirschfeld. Cf. also Gerndt (note 121), p. 106–28.

124 A. von Buttlar (see note 37), p. 187.

125 In 1777, during the American War of Independence, the British army surrendered at Saratoga. Serving in it were about 15,000 Hessians, hired out by the Landgrave.

126 Friedrich von Rebmann, *Wanderungen und Kreuzzüge durch einen Theil Deutschlands, von Anselmus Rabiosus dem Jüngern* (Altona, 1795), quoted by Gerndt (note 121), p. 126.

127 It is often pointed out that the Dutch garden too was laid out geometrically. Hence the form was not exclusive to absolutist régimes.

128 See Hartmann (note 69), p. 75ff.; A. Hoffmann, *Der Landschaftsgarten* (Hamburg, 1963), p. 13ff.; A. von Buttlar (see note 37) p. 7ff.; on the influence of freemasonry see G. Hajós, 'Die neuentdeckte Landschaft der Wiener "Gegenden" und die Freimaurerei in den Englischen Gärten der Spätaufklärung', *Kunsthistorisches Jahrbuch Graz*, XXIII (1987), pp. 96–116.

129 See Hartmann (note 69), p. 158ff., and more generally A. von Buttlar (note 37), p. 36, 47.

130 A. von Buttlar (note 37), p. 14; similarly Hirschfeld (note 118), I, p. XIII.

131 Gerndt (note 121), p. 64; on p. 183, n. 13, Gerndt gives titles of horticultural works of the period, e.g. Johann Georg Kessel, *Ein Landschaftsgemälde für Freunde der schönen Natur und ländlicher Anlagen* (Erlangen, 1786), and Christian Ludwig Stieglitz, *Gemählde von Gärten, im neueren Geschmack dargestellt* (Leipzig, 1798).

132 Hirschfeld (note 118), I (Leipzig, 1779), p. 170.

133 Further comparisons between gardens and galleries are cited by A. von Buttlar (note 37), pp. 14, 43f.; Hennebo (note 35), pp. 92, 99. In 1821 Klenze commended his Walhalla design to the Crown Prince with a comparison: 'If there was ever a painting that must in itself be something quite splendid and self-contained it is the Walhalla'; see Traeger (note 25 above), p. 185.

134 See also Arndt (note 48), p. 182.

135 Cited by A. von Buttlar (note 37), p. 16. Cf. also H.-W. Jäger, *Politische Metaphorik im Jakobinismus und im Vormärz* (Stuttgart, 1971), p. 34ff, with further examples.

136 Quoted by Gerndt (note 121), p. 128.

137 All the quotations are taken from the description in Gerndt (note 121), pp. 169–77. On the tendency see also A. von Buttlar, 'Englische Gärten in Deutschland. Bemerkungen zur Modifikation ihrer Ikonologie', *Sind Briten hier? Relations Between British and Continental Art 1680–1880* (Munich, 1981), p. 113ff.

138 Goethe, *Wahlverwandtschaften*, part 2, ch. 8.

139 A. von Buttlar (note 37), p. 17.

140 P. Grobe, *Die Entfestigung Münchens* (abbreviated version of diss. Technische Hochschule, Munich, 1969), p. 23.

141 On the monuments in Regensburg, including one to Kepler (1803), see Traeger (note 25), p. 121ff.

142 See the catalogue *Zauber der Medusa* (Vienna, 1987), no. VIII/3. A female landscape giant from the Netherlands, 16th century, recently acquired by the Brussels Museum, is reproduced in the supplement to the *Gazette des Beaux-Arts*, CXXXI (1989).

143 Cf. H. Bredekamp, 'Die Erde als Lebewesen', *Kritische Berichte*, 4/5 (1981), pp. 5–37.

144 B. M. Stafford, 'Rude Sublime: The Taste for Nature's Colossi during the late Eighteenth and Early Nineteenth Centuries', *Gazette des Beaux-Arts*, LXXXVII (1976), pp. 114, 116.

145 See the catalogue *Die Rückkehr der Barbaren. Europäer und Wilde in der Karikatur Daumiers*, compiled by A. Stoll (Hamburg, 1985), p. 148, no. II.5.

146 W. Körte, 'Deinokrates und die barocke Phantasie', *Die Antike*, XIII (1937), p. 291; W. Oechslin, 'Dinokrates – Legende und Mythos megalomaner Architekturstiftung', *Daidalos*, IV (1982), pp. 7–26.

147 Cf. Bredekamp (note 112).

148 Körte (note 146), pl. 22.

149 Fajardo, *Idea de un Principe Politico Cristiano* (1640), II (Madrid, 1927), p. 137; on fear of giants see *ibid.*, III, p. 131; Henkel and Schöne (note 62), col. 59.

150 On Fischer von Erlach see G. Kunoth, *Die Historische Architektur Fischer von Erlachs* (Düsseldorf, 1956), p. 54f.

151 E. M. Vetter, 'Der Einzug Philipps III. in Lissabon 1619', *Spanische Forschungen der Görresgesellschaft*, XIX (1962), p. 205.

152 From 'The Wandering' (Die Wanderung) of 1801; *Samtliche Werke*, ed. F. Beissner (1944–).

153 Körte (note 146), p. 291. On the experience at the mountaintop see H. J. Neidhardt, 'Das Gipfelerlebnis in der Kunst um 1800', in P. Betthausen, ed., *Studien zur deutschen Kunst und Architektur um 1800*

(Dresden, 1981), esp. 104ff. ('Piedestal des Grossen Menschen', in which, however, the ruler does not figure). On Napoleon's picture-puzzle in a landscape with the lemma 'sic transit gloria Regum', see the article by W. S. Heckscher and K.-A. Wirth on 'Emblem, Emblembuch', *Reallexikon zur Deutschen Kunstgeschichte*, v (Stuttgart, 1967), col. 219.

154 The photograph of the Lenin sculpture was published in *Der Querschnitt*, v (1925), before p. 416.

155 *Süddeutsche Zeitung*, 28/29 July 1990.

156 Körte (note 146), p. 291.

157 R. Higgins, 'Der Koloss von Rhodos', in P. A. Clayton and M. J. Price, *Die Sieben Weltwunder* (Stuttgart, 1990), pp. 164–81.

158 A. Condivi, *Vita di Michelangelo Buonarroti* (1553), edited by E. S. Barelli (Milan, 1964), cap. 24. An inscription in Bomarzo recalls the Colossus of Rhodes, which is intended to enhance the fame of Orsini's wood; cf. Bredekamp (note 112), p. 101f.

159 M. Trachtenberg, *The Statue of Liberty* (New York, 1976).

160 See the catalogue *Die Hanse*, ii (Hamburg, 1989), p. 594.

161 Catalogue *Münzen und Medaillen des Österreichischen Heldenzeitalters 1683–1794; Europalia 87* (Charleroi and Bruges, 1987–8), no. 445.

162 Johann Nepomuk Sepp, *Ludwig Augustus, König von Bayern und das Zeitalter der Wiedergeburt der Künste* (2nd edn Regensburg, 1903), p. 426, quoted by E. Bierhaus-Rödiger, 'Die historische Landschaftsmalerei in München unter König Ludwig I.', in the catalogue *Münchener Landschaftsmalerei 1800–1850* (Munich, 1979), p. 129.

163 In the Historisches Museum, Berlin.

164 R. Schoch, in the catalogue *Freiheit, Gleichheit, Brüderlichkeit. 200 Jahre Französische Revolution in Deutschland* (Nuremberg, 1989), p. 505. The passage is from Thomas Aquinas, *De regimine principum* (see note 110 above), lib. 1, cap. 10. On pictures of the Alps cf. the catalogue *Zeichen der Freiheit* (Berne, 1991), p. 393ff.; also Ruth and Dieter Groh, 'Von den schrecklichen zu den erhabenen Bergen. Zur Entstehung ästhetischer Naturerfahrung', *idem*, *Weltbild und Naturaneignung* (Frankfurt am Main, 1991), pp. 92–149.

165 Quoted by H. Beenken, *Das Neunzehnte Jahrhundert in der deutschen Kunst* (Munich, 1944), p. 159f.

166 See the catalogue *Deutschland und die Französische Revolution* (Goethe-Institut Stuttgart, 1989), no. x, pl. 3, p. 190; the catalogue *Freiheit, Gleichheit, Brüderlichkeit* (Nuremberg, 1989), no. 410 (sepia drawing in the Kunsthalle, Hamburg). L. R. von Lutterotti, *Joseph Anton Koch* (Vienna and Munich, 1985), cat. G 2.

167 In the catalogue *Joseph Anton Koch. Ansichten der Natur* (Stuttgart, 1989), no. 25, Christian von Holst, referring to the sepia drawing, speaks of the water 'eating into the rock by regressive erosion'.

168 L. R. von Lutterotti (note 166), cat. Z 300.

169 See the catalogue *Goya. Das Zeitalter der Revolutionen. 1789–1830* (Hamburg, 1980–81), no. 220.

170 I. Baxmann, *Die Feste der Französischen Revolution. Inszenierung von Gesellschaft als Natur* (Weinheim and Basle, 1989), p. 155.

171 H.-C. and E. Harten, *Die Versöhnung mit der Natur* (Reinbek, 1989), p. 128 and pl. ix.

172 Baxmann (note 170), p. 103.

173 There is copious material in the Hague Decimal Index 46 C 1.

174 Catharijneconvent, Utrecht. Cf. the catalogue *De Euwen van de Beeldenstorm. Ketters en papen onder Filips II* (Utrecht, 1986), p. 38.

175 See H. Schneider, 'Een Toeschrijving aan Govert Jansz., alias Mijnheer', *Oud-Holland*, xliii (1927), pp. 269–71.

176 On the miniature in the grammar for the prince by E. Donati see the catalogue *Arte Lombarda* (Milan, 1958), no. 454, where it is attributed to Giovanni P. Birago. In Hans Burgkmair's woodcut showing Charles V between Virtus and Voluptas there is also no sign of differentiation in the landscape.

177 E. Panofsky, *Herkules am Scheideweg* (Leipzig and Berlin, 1930), p. 117, ill. 57a, with a portrait head of Maximilian inserted; Hollstein (note 33), p. 156; the catalogue *Wittelsbach und Bayern*, II/2 (Munich, 1980), no. 183; also Rubens's *The Cardinal-Infant Ferdinand as Hercules at the Parting of the Ways*; see also J. Langner, 'Die Erziehung der Maria Medici', *Münchner Jahrbuch*, XXX (1979), p. 120, ill. 13.

178 Cf. V. Sgarbi, 'Cariani a Ferrara e Dosso', *Paragone*, 389 (1982), pp. 6–8; and the catalogue *The Genius of Venice* (London, 1983), no. 26.

179 Two examples: M. Perry, 'Candor Illaesus . . .', *Burlington Magazine*, CXIX (1977), p. 676 (a landscape for Pope Clement VII, with a peaceful region and chaos); E. Langmuir, 'Arma virumque . . . Nicolò dell'Abate's Aeneid Gabinetto for Scandino', *Journal of the Warburg and Courtauld Institutes*, XXXIX (1976), p. 163.

180 D. M. Bergeron, 'Symbolic Landscapes in English Civic Pageantry', *Renaissance Quarterly*, XXII (1969), p. 33ff.

181 See the catalogue *Illustrierte Flugblätter* (Coburg, 1983), no. 93.

182 See the catalogue *Münzen und Medaillen des Österreichischen Heldenzeitalters 1683–1794*; see also *Europalia 87* (Charleroi and Bruges, 1987/8), no. 411.

183 H. W. Keiser, *Gemäldegalerie Oldenbourg* (Oldenburg, 1966), p. 123; and the catalogue *Angelica Kauffmann und ihre Zeitgenossen* (Vienna and Bregenz, 1968–9), no. 335.

184 E. Schlocke, *Das politische Plakat* (Munich, 1939), p. 36.

185 See H. Laag, 'Sonne', *Lexikon der christlichen Ikonographie* (Rome and Freiburg 1972), IV, cols 175–78; Henkel and Schöne (note 62), col. 1268; 'Ewigkeit' (anonymous), *Reallexikon zur Deutschen Kunstgeschichte*, VI (Munich, 1973), col. 633. J. Gelli, *Divise-Rotti e Imprese di Famiglie e Personaggi Italiani* (Milan, 1928), no. 188: sunshine = divine benevolence.

186 C. Ruelens and M. Rooses, *Codex Diplomaticus Rubenianus*, 6 vols (Antwerp, 1887–1909), IV, p. 36; Saavedra Fajardo (note 149, I, p. 153f.

187 D. de Chapeaurouge, 'Theomorphe Porträts der Neuzeit', *Deutsche Vierteljahresschrift*, XLII (1968), p. 271ff; E. M. Vetter, 'Der Einzug Philipps III. in Lissabon 1619', *Spanische Forschungen der Görresgesellschaft*, XIX (1962), p. 251.

188 On sixteenth-century France see R. A. Jackson, 'The Sleeping King', *Bibliothèque d'Humanisme et Renaissance*, XXXI (1969), esp. p. 543ff.

189 M. Raveganani Morosini, *Signorie e Principati. Monete italiane con ritratto 1450–1796*, II (Dogana, 1984), pp. 80, 88.

190 Catalogue *Le Medaglie del Soldani per Cristine di Svezia* (Florence, 1983), no. 4b; the earliest example known to me of a sun with the face of a prince in it is on Filarete's medal showing him freeing a swarm of bees from a tree-trunk under the sun of the prince's favour; cf. C. F. Hill, *A Corpus of Italian Medals of the Renaissance before Cellini* (London, 1930), nos. 625 and 905.

191 On the tondo by A. L. Girodet-Trioson see the catalogue *Wittelsbach und Bayern*, vol. III/2 (Munich, 1980), no. 432; cf. also the catalogue *Europa 1789* (Hamburg, 1989), nos. 497 and 498.

192 See the catalogue *Porträt I: Herrscher* (Münster, 1977–8), no. 110; J. Adhémar, 'La Légende napoléonienne', *Revue du Louvre*, XIX (1969), p. 182.

193 Pictorial history took note of this: just as in 1904 Emperor Matsuhito

could appear on a postcard as a rising sun, so Czar Nicholas could be submerged in the sea, as a declining ruler; see R. Lebeck and M. Schütte, *Propagandapostkarten*, 1 (Dortmund, 1980), nos. 41, 42.

194 J. Typotius, *Symbola divina et humana* . . . 111 (Prague, 1601–3, repr. 1972), p. 171. Gelli (as note 185), no. 1283.

195 P. P. Galeotti's medal in G. F. Hill and G. Pollard, *Renaissance Medals from the S. H. Kress Collection at the U.S. National Gallery of Art* (London, 1967), no. 354 reverse.

196 See the catalogue *Wittelsbach und Bayern* (Munich, 1980), vol. 11/2, no. 247.

197 Vetter (note 187), p. 200.

198 See the catalogue *Die Welt im Umbruch* (Augsburg, 1980), 1, no. 432.

199 See the catalogue *Ereignis Karikaturen* (Münster, 1983), no. 46.

200 M. G. Roethlisberger, 'Some Early Clouds', *Gazette des Beaux-Arts*, CXI (1988), p. 285.

201 Hill (note 190), no. 419a. On the various connotations of Jove's lightning in princely iconography see M. Beller, 'Jupiter Tonans', *Beihefte zum Euphorion*, fasc. 13 (Heidelberg, 1979).

202 E. Bierhaus-Rödiger, 'Die historische Landschaftsmalerei in München unter König Ludwig I.', in the catalogue *Münchner Landschaftsmalerei 1800–1850* (Munich, 1979), p. 144. For the sketch for this encaustic painting in the palace of Charlottenburg see the catalogue *Galerie der Romantik* (Nationalgalerie, Berlin, 1986), p. 23.

203 D. Meisner and E. Kieser, *Politisches Schatzkästlein* (1625–31, repr. Unterschneidheim, 1979), no. 33. See also Henkel and Schöne (note 62), col. 1619.

204 J. W. Zincgref, emblem no. 39 in the Heidelberg edition of 1619.

205 *Emporium* XIV (December 1989), no. 2197.

206 Henkel and Schöne (note 62), cols. 14, 16, 23, 286.

207 Museum Folkwang, Essen. Cf. H. Börsch-Supan, *C. D. Friedrich* (Munich, 1973), no. 249; *c.* 1818.

208 K. D. Pohl, *Allegorie und Arbeiter*, diss., Osnabrück, 1986, ill. 119.

209 Kunsthaus, Zurich. On commitment in war cf. Bätschmann (note 103), p. 205f.

210 M. German, *Die Kunst der Oktoberrevolution* (Düsseldorf and Leningrad, 1986), ill. 248.

211 See the catalogue *Politische Plakate der Weimarer Republic* (Hamburg, 1982), no. 152.

212 Henkel and Schöne (note 62), cols. 221, 226, 686, 930, 1092.

213 On the imagery of bees see D. Peil, *Untersuchungen zur Staats- und Herrschaftsmetaphorik in literarischen Zeugnissen von der Antike bis zur Gegenwart* (Munich, 1983), pp. 166–301, where 'shepherd and flock', the ship of state, peril at sea and shipwreck are treated at length, but with few pictorial examples.

214 R. Schoch, 'Palast und Hütte. Zum Bedeutungswandel eines künstlerischen Motivs zwischen Aufklärung und Romantik', *Kritische Berichte*, 4 (1984), pp. 42–59; see also the catalogue *Freiheit, Gleichheit, Brüderlichkeit* (Nuremberg, 1989), pp. 240–46. On the Netherlands see note 67 above.

215 F. Bacon, 'Of Seditions and Troubles'. On storm images see H. Rahner, *Symbole der Kirche* (Salzburg, 1964), pp. 272–80, and the recent literature in H. S and I. Daemmrich, *Themen und Motive in der Literatur* (Tübingen, 1987). See also E. Hüttinger, 'Der Schiffbruch. Deutungen eines Bildmotives im 19. Jahrhundert', *Beiträge zur Motivkunde des 19. Jahrhunderts* (Munich, 1970), pp. 211–44.

216 Hill (note 190), no. 625.

217 See the catalogue *Wenzel Hollar* (Berlin, 1984), no. 74. See also Henkel
and Schöne (note 62 above), col. 68.
218 B. E. Hildebrand, *Sveriges och svenska kongunghahusets minner penningar,
praktmynt och belöningsmedaljer* (Stockholm, 1874–5), no. 7.
219 *Emporium* XIV (December 1989), no. 1989.
220 Hill (note 190), no. 55 reverse.
221 Cf. Erasmus, *Institutio Principis Christiani* (Paderborn, 1968), p. 45;
similarly Chodowiecki 1792. Cf. the catalogue *Goya. Das Zeitalter der
Revolutionen 1789–1830* (Hamburg, 1980), no. 324; W. Speyer,
'Gewitter', *Reallexikon für Antike und Christentum*, x (Stuttgart, 1978),
cols. 1108–72; L. O. Goedale, *Tempest and Shipwreck in Dutch and Flemish
Art* (London, 1989).
222 H. G. Koenigsberger, 'Republics and Courts in Italian and European
Culture in the Sixteenth and Seventeenth Century', *Past & Present*,
LXXXIII (1979), p. 52; C. Uhlig, *Hofkritik im England des Mittelalters und
der Renaissance* (Berlin, 1973), pp. 33, 61, 181, 186, 207; P. M. Smith, *The
Anticourt Trend in Sixteenth-Century French Literature* (Geneva, 1966),
p. 39, n. 3.
223 Saavedra Fajardo (note 149 above), III, p. 243.
224 Machiavelli, *Il Principe*, cap. 25. See the convincing interpretation by
R. Brandt, 'Pictor philosophus: Nicolas Poussin, "Gewitterlandschaft
und Pyramus und Thisbe"', *Städel-Jahrbuch*, XII (1989), esp. p. 251ff.;
also S. McTighe, 'Nicolas Poussin's representations of storms and
Libertinage in the mid-seventeenth century', *Word & Image*, v (1989),
pp. 333–61.
225 See the catalogue *Münzen in Brauch und Aberglauben* (Nuremberg, 1982),
no. 26c; the medal of 1709 celebrating the battle of Malplaquet in the
sale catalogue Lanz 51 (28 Nov 89), no. 131; cf. also G. van Loon,
Histoire Métallique des XVII Provinces des Pays-Bas, 5 vols (Paris, 1732–
34), v, pl. 145/4; also *Emporium*, XIV (December 1989), no. 2665;
H. Junius, *Emblemata* (1565; Antwerp 1902), p. 47, emblem XLIII.
226 Henkel and Schöne (note 62), cols. 221, 226, 686, 930.
227 Shakespeare, *Richard II*, III, scene iv.
228 G. A. Böckler, *Ars Heraldica* (Nuremberg, 1688), quoted by Walter
Benjamin, *Ursprung des deutschen Trauerspiels* (Frankfurt am Main,
1963), p. 192.
229 Van Loon (note 225), vol. 2.
230 Henkel and Schöne (note 62), cols. 221, 226.
231 Though no definitive meaning can be suggested, an important part is
played in emblematism by pots, jugs and cans (Henkel and Schöne, *op.
cit.*, col 1380) or birds over clouds (*ibid.*, cols. 1380, 823, 826: the wise
man avoids the storms of Fortuna).
232 R. Piepmeier, 'Landschaft', J. Ritter and K. Gründer, eds, *Historisches
Wörterbuch der Philosophie*, v (Basle and Stuttgart, 1980), col. 17. This
viewpoint is developed and also radicalized in Oskar Bätschmann's
book (see note 103).

List of Illustrations

23 Meindert Hobbema, *The Avenue at Middelharnis*, 1689, oil. National Gallery, London.

24 Ferdinand Hodler, *Autumn Evening*, 1892, oil. Musée d'Art et d'Histoire, Neuchâtel.

25 Monument near Köttweinsdorf in Franconia, set up by the master-butcher Otto Wich, 1767. Photo: Bayerisches Landesamt für Denkmalpflege, Munich.

26 Medieval penitential cross at Lauingen, on the road to Birkach, Swabia. Photo: Bayerisches Landesamt für Denkmalpflege, Munich.

27 Johannes Schilling and Karl Weisbach, The Niederwald monument, 1877–83, at Rüdesheim am Rhein. Photo: Bayerisches Landesamt für Denkmalpflege, Munich.

28 A postcard of *c*. 1899 showing Bruno Schmitz's design for the 1892–6 Kyffhäuser monument near Bad Frankenhausen, Halle. Photo: Bayerisches Landesamt für Denkmalpflege, Munich.

29 Karl Friedrich Schinkel, Sketch of the design for the Kreuzberg monument, 1823. Kupferstichkabinett, Nationalgalerie, Berlin. Photo: Staatliche Museen zu Berlin.

30 Leo von Klenze, *Walhalla*, 1836, oil. The Hermitage, Leningrad.

31 Stephan Lochner, *The Last Judgment*, *c*. 1435, oil. Wallraf-Richartz-Museum, Cologne. Photo: Rheinisches Bildarchiv, Cologne.

32 Mathäus Merian, Sketch of Heidelberg, 1619–20. Kupferstichkabinett, Berlin. Photo: Staatliche Museen für Preußischer Kulturbesitz, Berlin/ Jörg P. Anders.

33 Attributed to Altobello Melone, *Portrait of a Woman*, *c*. 1510, location unknown.

34 Upper Rhenish Master, Detail of the rocky background to an *Allegory of Death*, *c*. 1480, oil on panel. Germanisches Nationalmuseum, Nuremberg.

35 Vittore Carpaccio, *Sacra Conversazione*, *c*. 1500, tempera. Musée des Beaux-Arts, Caen.

36 Andrea Mantegna, Detail of the rocky background in a fresco of *c*. 1460 in the Camera degli Sposi of the Palazzo Ducale, Mantua.

37 Part of the medieval fortress of San Leo in the Marche, restored *c*. 1480 by Francesco di Giorgio.

38 Michael Pacher, Detail of the rocky background to the *St Wolfgang Altar*, *c*. 1471–81, oil. Church of St Wolfgang, Sankt Wolfgang, Austria. Photo: Bundesdenkmalamt Austria.

39 Jan van Eyck, *Virgin and Child with Nicolas Rolin*, *c*. 1436, oil. Musée du Louvre, Paris. Photo: Service Photographique de la Réunion des Musées Nationaux.

40 Postcard view of Liechtenstein Castle, Liechtenstein.

41 General Ambrogio Spinola, surrounded by the places he has captured, 1621, engraving. Koninklijk Bibliotheek, The Hague.

42 Peter Paul Rubens, *Henri IV of France at the Battle of Ivry* (1590), *c*. 1628–31, oil. Uffizi, Florence. Photo: Bem. Foto Fine Art Engravers; © Conzett & Huber, Zürich.

43 Giorgo Vasari, Drawing of the Battle of San Secondo, *c*. 1555. Uffizi, Florence.

44 Albrecht Altdorfer, *The Battle of Alexander and Darius at Issus in 334 BC*, 1529, oil on panel. Alte Pinakothek, Munich. Photo: Bayerisches Staatsgemäldesammlungen, Munich.

45 A battle of 1602 between Maurice of Nassau and Duke Albrecht of Austria, engraving from Jan Orlers and Henrik van Haesten's *Description . . .* (Leiden, 1612).

46 Engraving of an officers' school, from Fleming's *Teutscher Soldat* of 1726.

47 The strategic situation at the Battle of Malplaquet (1709), from von Sachsen's *Art de la Guerre* of 1758.

48 Titian, *The Allocutio of General del Vasto, c.* 1540. Museo del Prado, Madrid.

49 Jacopo Tintoretto, *Portrait of General Pietro Pisani, c.* 1560, oil. Location unknown.

50 William of Nassau on horseback at the Siege of Groningen, engraving from a Dutch history of 1616 by Guillaume Baudart.

51 Peeter Snayers, *The Stadholder Isabella at the Siege of Breda, c.* 1630, oil. Museo del Prado, Madrid.

52 The Duke of Marlborough before the theatre of operations in the Low Countries, after 1706, engraving. Österreichisches Staatskriegsarchiv, Vienna.

53 Horace Vernet, *Napoleon at the Battle of Wagram (1809)*, 1836, oil. Musée National, Versailles. Photo: Service Photographique de la Réunion des Musées Nationaux.

54 Anton von Werner, *Count von Moltke at the Battle of Sedan*, 1884, oil. Lost. Photo: Rheinisches Bildarchiv, Cologne.

55 Girolamo Induno, *Garibaldi before Capua*, 1861, oil. Location unknown.

56 Engraving of a battlefield, from Fleming's *Teutscher Soldat* of 1726.

57 Franz von Stuck, *War*, 1894, oil. Bayerisches Staatsgemäldesammlungen, Munich.

58 Ludwig Meidner, *Apocalyptic Landscape, c.* 1912, oil. Staatsgalerie, Stuttgart.

59 Jørgen Sonne, *The Trenches at Dybbøl (1864)*, 1871, oil. Nationalhistoriske Museum på Frederiksborg, Hillerød. Photo: Lennart Larsen.

60 Paul Nash, *Battle of Germany*, 1944, oil. Imperial War Museum, London.

61 Fritz Erler, *Death of Ypres*, 1915, pencil, watercolour and body colour. Staatliche Graphische Sammlung, Munich.

62 Paul Klee, *The War that Devastates the Land*, 1914, pen and ink. Kunstmuseum Basle. Photo: Öffentliche Kunstsammlungen Basel, Kupferstichkabinett.

63 Otto Dix, *Flanders*, 1934–6, mixed media. Nationalgalerie, Berlin. Photo: Staatliche Museen für Preußischer Kulturbesitz, Berlin/Jörg P. Anders.

64 *Theme: CERTAINTY. The next world war will certainly be the last one*, a 1981 poster by Klaus Staeck. Photo: Museum für Kunst und Gewerbe, Hamburg.

65 Israël Silvestre, Engraving of a bird's-eye view of the grounds at Versailles, *c.* 1690. Musée du Louvre (Department des Arts Graphiques), Paris. Photo: Service Photographique de la Réunion des Musées Nationaux.

66 William Kent, The Temple of British Worthies at Stowe Park, Bucks, 1735.

67 View of the park at Méréville, after Constant Bourgeois, in Alexandre-Louis-Joseph, Comte de Laborde's *Description des nouveaux jardins de la France . . .*, Paris, 1808–14. Studies in Landscape Architecture Photo Archive, Dumbarton Oaks, Washington, DC.

68 Hercules above the cascade at the Wilhelmshöhe, Kassel, after 1696. Photo: Bildarchiv Foto Marburg.

69 François Cuvilliés the Younger, Plan of the buildings and gardens at Schloss Nymphenburg, near Munich, 1772, engraving. Bayerische Verwaltung der Staatliche Schlösser, Nymphenburg. Photo: Museumabteilung Schloss Nymphenburg.

70 Ludwig Emmert, The replanning of the park at Nymphenburg, 1837,

engraving. Bayerische Verwaltung der staatlichen Schlösser, Nymphenburg. Photo: Museumabteilung Schloss Nymphenburg.

71 Johann Bernhard Fischer von Erlach, Engraving of Chinese-style artificial mountains, from *Entwurf einer historischen Architektur* (Vienna, 1721).

72 Engravings of rockwork, after Vernet's paintings of designs for a park laid out by George Le Rouge, from *Cahier* XII of Le Rouge's *Jardins anglo-chinois*, Paris, 1767–87. Studies in Landscape Architecture Photo Archive, Dumbarton Oaks, Washington, DC.

73 Joos de Momper, *Head-landscape*, before 1635, oil. Private collection, Basel.

74 G. B. Braccelli, A city as a sleeping giant, an etching from his *Bizarreries* of 1624.

75 Jean-Baptiste Debret, *The Sleeping Giant*, an engraved travel illustration of the Brazilian coast.

76 Title-page of Thomas Hobbes's *Leviathan* (London, 1651). Photo: Herzog August Bibliothek, Wolfenbüttel.

77 *One People – One Reich*, an Austrian propaganda postcard of 1928.

78 Honoré Daumier, *Le Réveil de l'Italie*, lithograph, 1859.

79 Pietro da Cortona, Drawing of the artist showing Pope Alexander VII a realisation of Dinocrates' project for the Mount Athos monument to Alexander the Great.

80 Pierre-Henri de Valenciennes, *Mount Athos, Carved as a Monument for Alexander the Great, as proposed by Dinocrates, holding a town in one hand and a river in the other*, 1796, oil. Art Institute of Chicago.

81 After Johann Bernhard Fischer von Erlach, Engraving of the Mount Athos monument of Dinocrates to Alexander the Great, 1721.

82 Josef Atzel's planned monument for Frederick the Great, 1770, engraving.

83 Korczak Ziolkowski and family, model for the Crazy Horse Mountain mountain monument to the Sioux chief Crazy Horse, South Dakota. Photo: Süddeutscher Verlag, Munich.

84 Gutzon Borglum, mountainside portraits of George Washington, Thomas Jefferson, Theodore Roosevelt and Abraham Lincoln, the founding fathers of American democracy, 1927–41, Mount Rushmore, South Dakota. Photo: Suddeutscher Verlag, Munich.

85 Temple figures of Ramesses II hewn in the sandstone cliff of Abu Simbel, Egypt (xixth Dynasty, *c.* 1290–1224 BC).

86 A cartoon by Low in the *Evening Standard* of the 'Hoover face-building enterprise', 1929.

87 Rock-monument to Lenin in the Crimea, *c.* 1925.

88 Monument to President Marcos near Baguio in the Philippines.

89 Nikolai Tomski's Lenin monument of *c.* 1966–9 (until 1991 it stood in the former Leninplatz in Friedrichshain, Berlin). Photo: Deutsche Fotothek, Dresden.

90 Philip Galle, after Maarten van Heemskerck, An engraved reconstruction of the Colossus of Rhodes, 1572. Rijksmuseum, Amsterdam.

91 Maarten van Heemskerck, Detail from *Panoramic Landscape with the Abduction of Helen*, showing the harbour at Rhodes, 1535, oil. Walters Art Gallery, Baltimore.

92 Martin Brunner, The collapse of the Colossus of Rhodes, on a silver medal of 1709. Sammlung von Medaillen, Kunsthistorisches Museum, Vienna.

93 Sebastian Dadler, Mercury as a harbour sculpture, on a silver medal of 1636. Museum für Hamburgische Geschichte, Hamburg.

94 James Gillray, *Destruction of the French Colossus*, engraving, 1798.
 Museum für Kunst und Gewerbe, Hamburg.
95 *The Colossus*, An engraving depicting the State as bountiful yet corrupt,
 standing on legs of Lust and Fraud, 1767. Photo: Pierpont Morgan
 Library, New York.
96 A colossus with a French military *képi* devastates the Ruhr, on a
 German wooden practice target, probably after 1923. Deutsches
 Historisches Museum, Berlin.
97 Emil Schaudt and Hugo Lederer, Drawing of a design for the Bismarck
 monument in Hamburg, 1901.
98 A. Desperet, *The Third Eruption of the Volcano of 1789*, from the journal
 La Caricature, 1833. Museum für Kunst und Gewerbe, Hamburg.
99 Joseph Anton Koch, Sketch of a waterfall, 1793/4. Kunsthalle,
 Hamburg. Photo: Elke Walford.
100 Joseph Anton Koch, *Waterfall*, 1796, oil. Kunsthalle, Hamburg. Photo:
 Elke Walford.
101 Joseph Anton Koch, *Falls of the Rhine*, 1791, sepia ink drawing with
 white highlights. Graphische Sammlung, Staatsgalerie, Stuttgart.
102 Francisco de Goya, *Landscape with a Waterfall*, 1810, etching.
103 Claude-Louis Châtelet, *The Waterfall on the Fiume Grande*, before 1794,
 gouache on beige paper with a prepared ground.
104 The site of the Spanish Steps in Rome transformed into a landscape in
 honour of a visit by the French Dauphin, 1662.
105 Alexandre-Théodore Brongniart's design for a holy mount in Bordeaux
 Cathedral, 1794.
106 Engraving of the holy mount for the festival of the Supreme Being,
 Paris, 1794, staged by Jacques Louis David.
107 Circle of Gillis Mostaert, *The Broad and Narrow Ways*, c. 1580, oil.
 Rijksmuseum Het Catharijneconvent, Utrecht.
108 Govert Jansz., *The Narrow and Broad Ways*, c. 1600, oil. Location
 unknown. Photo: RKD.
109 Milanese miniature showing Massimiliano Sforza choosing between
 Virtue and Vice, c. 1496. Biblioteca Trivulziana, Milan.
110 Jan Sadeler the Elder after Friedrich Sustris, Prince Maximilian of
 Bavaria as Hercules at the parting of the ways, 1595. Staatliche
 Graphische Sammlung, Munich.
111 Giovanni Cariani, *Fortuna between Natura and Musica*, c. 1515, oil. M.
 Lanfranchi Collection, Rome.
112 François Guillaume Ménageot, *Allegory of War and Peace*, 1805, oil.
 Landesmuseum, Oldenburg. Photo: H. R. Wacker.
113 Andreas Bretschneider, *Europa Laments the State of War*, 1631, etching.
 Graphische Sammlung, Coburg. Photo: Kunstsammlungen der Veste
 Coburg.
114 J. F. Stieler, *The German Peace Interrupted, and Restored*, 1779. Sammlung
 von Medaillen, Kunsthistorisches Museum, Vienna.
115 British poster of c. 1917 illustrating the results of contrasting German
 and British aims.
116 A French poster for Bondartchouk's 1965 film of Tolstoy's *War and
 Peace*.
117 A 1924 poster for the German Social Democratic Party inviting voters
 to choose between peace and war. Photo: Hessisches Landesmuseum,
 Darmstadt.
118 Daniel Chodowiecki, *Enlightenment*, 1791, etching. Kunsthalle,
 Hamburg. Photo: Elke Walford.
119 Robert Guillaume Dardel, *Descartes Cuts through the Clouds of Ignorance*,
 1782, terracotta model for a monument. The Wallace Collection,
 London.

120 Gaspare Molo, Gold coin comparing Ferdinand Gonzaga, Duke of Mantua, to the sun, 1615.

121 Soldani's medal showing ex-Queen Christina of Sweden as the sun, (?) after 1660. Museo Nazionale del Bargello, Florence.

122 Laurent Dabos, Painting of Napoleon within a laurel wreath and sunlight, 1806, oil. Bayerische Staatsgemäldesammlungen, Munich.

123 J. W. Zincgref, Emblem, showing the King as the Sun, 1619.

124 Jean Mauger, Medal of Louis XIV as the sun, 1667. British Museum, London.

125 Dutch engraving after a medal following the death of the King of Bohemia, 1632. Bayerlische Staatsbibliothek, Munich.

126 Giovan Jacopo Trivulzio, A device, after Typotius's *Symbola* . . . (Prague, 1601/03).

127 Alms money showing the blessings of the rule of Maximilian I of Bavaria, *c.* 1615. Staatliche Münzsammlung, Munich.

128 Pier Paolo Galeotti, sun over the sea, from a medal of Tommaso Marino, Duke of Terranuova, *c.* 1552. National Gallery of Art, Washington, DC (Samuel H. Kress Collection).

129 Bronze medal, after Danese Cattanneo, for Giovanni de' Medici delle Bande Nere, with lightning from a cloud, *c.* 1546.

130 Claude Lorrain, Drawing of clouds over Genoa, 1626/7. Holkham Hall, Norfolk.

131 Carl Rottmann, *The Battlefield of Marathon*, *c.* 1849, oil. Galerie der Romantik, Berlin. Photo: Staatliche Museen für Preußischer Kulturbesitz, Berlin.

132 Claude Lorrain, Drawing of a cloud seen as an omen of war, 1624. Library of Congress, Washington, DC.

133 Silver medal of 1755 showing the hopes attendant on the accession of Carl Georg Leberecht of Anhalt-Köthen.

134 J. W. Zincgref, emblem, showing the prince's favour, 1619.

135 Félix Vallotton, *Sunset*, 1917, oil. Kunsthaus Zürich. Photo: Kunsthaus Zürich, (Vereinigung Zürcher Kunstfreunde).

136 David Sterenberg, Panel design of the Sun of Liberty, 1918. State Museum of the Great October Socialist Revolution, Leningrad.

137 F. Stassen, *The New Day*, 1904, May Day news-sheet. Archiv der sozialen Demokratie, Bonn.

138 Wolf Willrich, Poster for the National Socialist Women's Movement, 1932. Hessisches Landesmuseum, Darmstadt.

139 Wenzel Hollar, The steadfastness of Charles I of England before his execution, 1649, engraving. Kupferstichkabinett, Staatliche Museen für Preußischer Kulturbesitz, Berlin.

140 A medal of 1529 for Francesco Guicciardini, showing the Governor as a rock in the storm.

141 A medal for Queen Louisa Ulrica of Sweden, showing the waves beating in vain against the rock, 1761.

142 A bronze medal by Webb in memory of William Pitt the Younger, showing a rock in stormy sea, 1806.

143 A bronze medal for Michel de l'Hôpital, Chancellor of France, showing a tower on a rock in the sea, struck by lightning, *c.* 1565. National Gallery of Art, Washington, DC (Samuel H. Kress collection).

144 Engraving after a medal showing the entry of the Spanish Infanta Maria Theresa into Paris to wed Louis XIV as rain falling on parched ground, 1660.

145 A silver 1630 double-thaler of Wilhelm, Landgrave of Hessen-Kassel, showing endurance in hard times: a tree bowed over in the storm. Germanisches Nationalmuseum, Nuremberg.

146 Nicolas Poussin, Drawing of a broken tree-trunk, *c.* 1629. Albertina, Vienna.

147 An emblem from Buck's *Emblemata Politica* of 1618, showing a split tree. Bayerisches Staatsbibliothek, Munich.

148 Engraving after a medal commemorating peace in the Low Countries, 1609.

149 *Natura Dictante Feror*, Emblem from Joachim Camerarius's *Symbolorum* of 1596. Photo: Universitätsbibliothek, Göttingen.

150 Peter Paul Rubens, *Polder Landscape with Cows, c.* 1621, panel. Alte Pinakothek, Munich. Photo: Bayerische Staatsgemäldesammlungen, Munich.